EXPLORING
PHOTOGRAPHY

BRYN CAMPBELL

Hudson Hills Press, Inc. New York

I owe thanks to many people for their help
in producing this book but above all to
Peter Riding, producer of the television
series *Exploring Photography*, and to
Roger Fletcher, who designed this book
itself. Their advice and encouragement
were invaluable to me. B.C.

First American Edition

© The Author and the British Broadcasting
Corporation 1978

All rights reserved under International and
Pan-American Copyright Conventions
First published by the British Broadcasting
Corporation, London 1978

Published in the United States by Hudson Hills Press,
Inc., New York. Trade distribution by Simon & Schuster,
a division of Gulf & Western Corporation, New York

Library of Congress Cataloging in Publication Data

Campbell, Bryn.
Exploring photography.

Resulted from the research involved for the BBC Tel-
evision series Exploring photography.
1. Photography, Artistic. 2. Exploring photography
(Television program) I. Exploring photography (Televi-
sion program)

TR642.C36 1979 770 79-13440

ISBN 0-933920-02-4

Manufactured in Japan

Contents

Cover photograph 'Monsoon' by Brian Brake

All other works throughout the book are captioned under the name of the photographer. Details of copyright ownership are given on page 144.

Introduction

This book resulted from the research involved for the BBC Television series of the same name. It is in fact the nucleus around which the programmes were created. Its purpose was defined at the outset as educational, that is, it was to be more simply didactic than just a display of great photographs and high cultural comment.

But we also decided to avoid the traditional 'How-to-do-it' approach. Our priority was to be the discussion of visual ideas, rather than practical instruction. We wanted to make it easier to understand the creative framework within which photographers operate, to reveal the factors that influence judgement. At the moment of exposure, this choice is often purely instinctive rather than premeditated. But an increased awareness of the available options probably helps to educate this instinct and so extend the range and complexity of one's work.

I say 'probably' because of a proper reluctance to sound too knowing about the nature of the creative process, such an elusive and anarchic phenomenon. But, at the very least, this heightened understanding should add to one's appreciation of great photography.

Although the book is made up of six distinct chapters, they should not be thought of too rigidly as neatly, self-contained areas. They overlap considerably. The divisions are simply a device that makes it easier to examine major areas of interest.

The same is true of the sub-divisions, the various creative alternatives that are outlined within each chapter. In practice, these elements are often inseparably involved. It is impossible to make a decision affecting one that does not affect another. But this admittedly artificial method of studying them separately, helps to explain their individual effects more simply.

What we have attempted is an introduction to the excitements of photography. It is not intended to be a comprehensive guide and one is keenly aware of the futility of attempting to define the essentially visual qualities of a fine image. But at a certain level it is possible to explain and to share one's enjoyment of pictures through words.

If you are trying to improve your own work, don't get bogged down by other people's rules and doctrines. Be adventurous and make your own decisions. The name of the game is *self*-expression.

BRYN CAMPBELL

1 The portrait

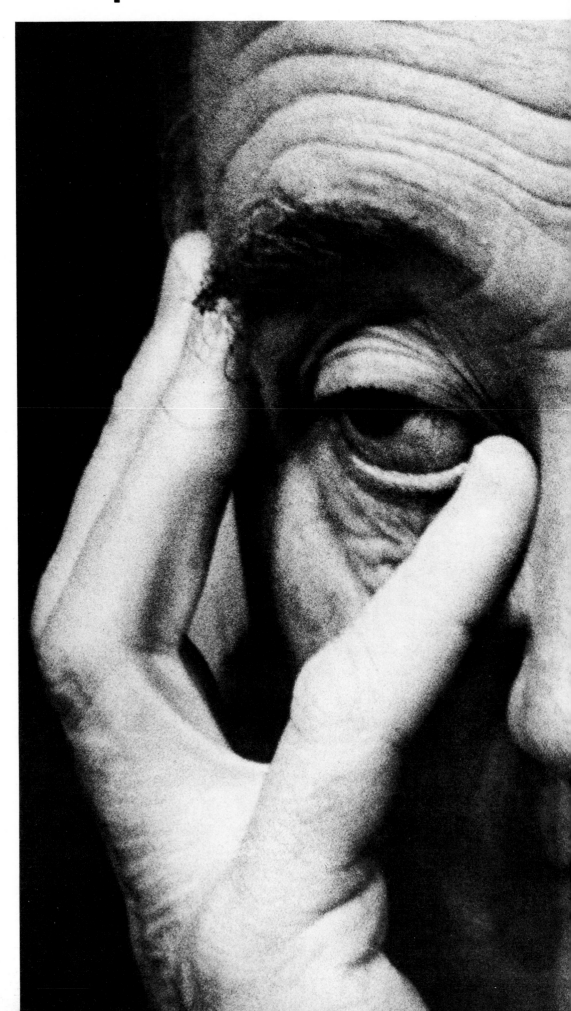

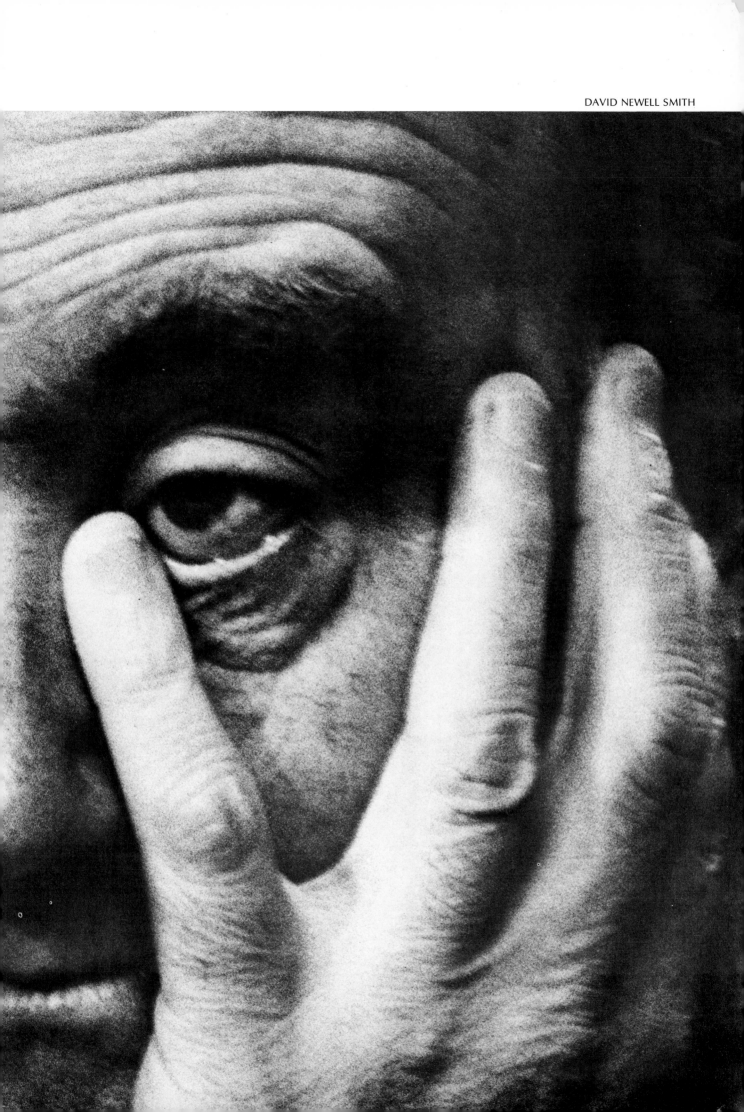

Portraiture might seem a relatively simple activity to describe. In very general terms it is but not if you try to define it more precisely.

What is a portrait? Just an image of another person? What about a picture of the back of someone's head, does that qualify? If not, what do you expect to learn that is so important just from the front of the head? Facial expression? Is that always so much more significant, than a very individual shape of head? How much of the face do you need to see? What if the eyes are somehow shadowed or covered? Does the subject have to be aware of the camera or does a candid shot count? If a full-length picture is acceptable, how small can the figure be in relation to the image area? Until it is no longer recognisable? By what, by features or by shape? Is a silhouette a portrait?

This enquiry is not just an academic exercise. It shows how arbitrary decisions have to be if one insists on defining creative activity. And it does help to question our preconceived ideas and priorities. It can suggest new possibilities of approach and subject-matter.

The opening portrait of William Whitelaw was taken at a Conservative Party conference. As a staff photographer for 'The Observer', David Newell Smith was experienced at covering political meetings and developed a technique for producing dramatic close-ups of the personalities on the platform. Using a 35mm camera fitted with a 500mm lens, i.e. about × 10 magnification, he could work from a reasonable distance and still fill the frame with just the subject's face. With patience he was able to capture a series of very expressive portraits.

It may sound easier than it was. The lens had a fixed aperture of about f8. Even in good indoor lighting, the viewfinder image would be none too bright and focusing had to be precise, such a long focal-length lens giving so little depth-of-field. Using a tripod was often impracticable and even after uprating the film-speed, he still had to hand-hold his camera at very slow shutter-speeds.

Some of his early results showed qualities that he could only describe as sculptural. He explored this effect and realised that it was particularly striking when the subject's hands were closely related to the face. The shapes of features and fingers were compressed into a dense image further strengthened by tight cropping.

IRVING PENN

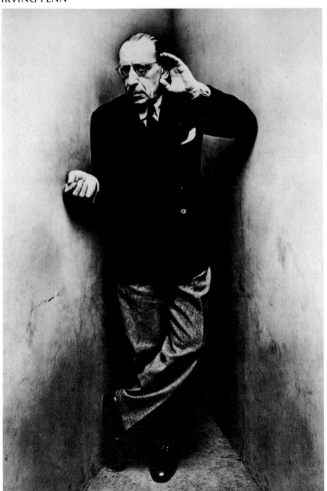

BRIAN GRIFFIN

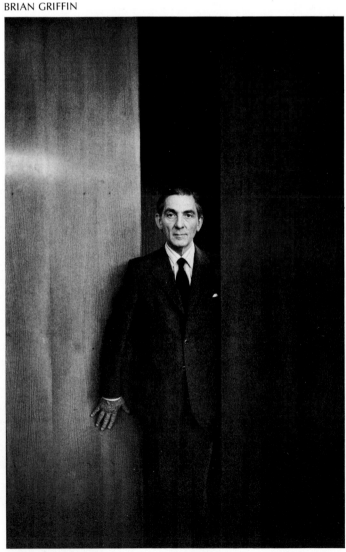

If a portrait is trimmed tight around the face, the background is usually irrelevant. One can work in the most chaotic surroundings. But as one tries to show more of the body or to introduce a sense of space, the problem of distracting elements in the picture can be very real. On location it may be hard to solve but in a studio one has the necessary control.

Some photographers always use a completely plain background, concentrating attention on the subject. The colour or tone of the background is important, as is the way it is lit, if one wants to keep this neutral quality. Once the setting becomes three-dimensional, the relationship with the subject becomes much more varied and complex. In each of the pictures below, the background is quite simple but there is an obvious dramatic tension between situation and subject.

The Irving Penn portrait of Stravinsky is one of a series he produced using the same technique of literally cornering his subject. The person is forced to come to terms physically and psychologically with these restrictions. The other results can be seen in Penn's book 'Moments Observed', if you can find a copy. They are rare and expensive. A good library is the best bet.

Brian Griffin took his photograph of Len Murray at TUC headquarters. He is used to working on location and taking advantage of whatever light and background is available. Often he is only given about ten minutes, so there is no time for elaborate preparations. He backs his visual judgement boldly, deciding on one definite idea and then making only subtle changes within that framework.

In this case he isolated the figure and gave it presence by carefully centering it between two large sliding doors. The overall feeling of space contrasts effectively with the tight positioning of the subject, increasing the visual tension around it. Then he concentrated on the precise placing of the hand and on the directness of expression in the eyes.

The background in Duane Michals' photograph, though tonally marked out into distinctly separate areas, could almost be mistaken for a flat surface. It is the posing of the hands that removes any conjecture. And yet the dark rectangle does seem to float above the lighter, cloud-like tones. So depending on how you look at it, the image creates an illusion of flatness or an illusion of depth. It also indicates depth but even that is essentially an illusion. It is after all just an image.

DUANE MICHALS

More exotic backgrounds can add visual interest to a portrait, give more information about the circumstances in which the picture was taken, or suggest something about the taste, personality or activities of the subject. Of course, if the background is too spectacular it can dominate the picture, becoming the principal subject itself.

Neal Slavin's photograph, the cover of his book on Portugal, is a delightful example of the use of a window, door or similar aperture, as an attractive frame – in this case actually a succession of frames. The window shape is very striking indeed but the face, finally framed by the head covering, is still strong enough to hold the centre of attention.

The watchman in William Klein's picture has such presence that it would not have been surprising if the photographer had simply concentrated on a close-up. But by showing him in a broader context, the image is so much richer in information, allusion, composition and even humour. The photograph became the lead picture for Klein's book, 'Rome'.

It is fascinating how the eye ranges over all the interesting detail and inevitably is drawn back to the figure of the man. His placing, well to the side of the picture, does not detract from the power or attraction. There is a stillness about this subject that is more complete than either the frozen violence of the statue or the stationary machine; a brooding intensity.

By printing the photograph with more than normal contrast, details of the man's features and dress stand out prominently. The white vest catches one's attention immediately and there is such a dramatic quality in the blackness of the hair and around the eyes.

Cecil Beaton appears first in this book as celebrity rather than photographer. The situation was more formal than in the previous pictures and the portrait was arranged in quite a different way.

With a probable choice of backgrounds, Ida Kar used this one, partly because it was sympathetic to the subject and partly because of its own visual appeal. It is a setting packed with busy detail and organising everything into one coherent image was far from easy. Notice how carefully the figure is placed so that the head is framed by an arch of foliage.

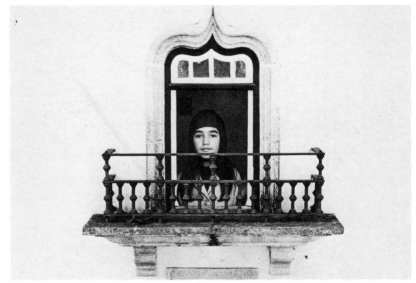

NEAL SLAVIN

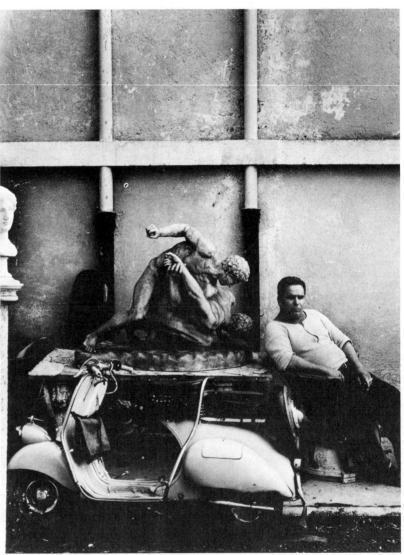

WILLIAM KLEIN

IDA KAR

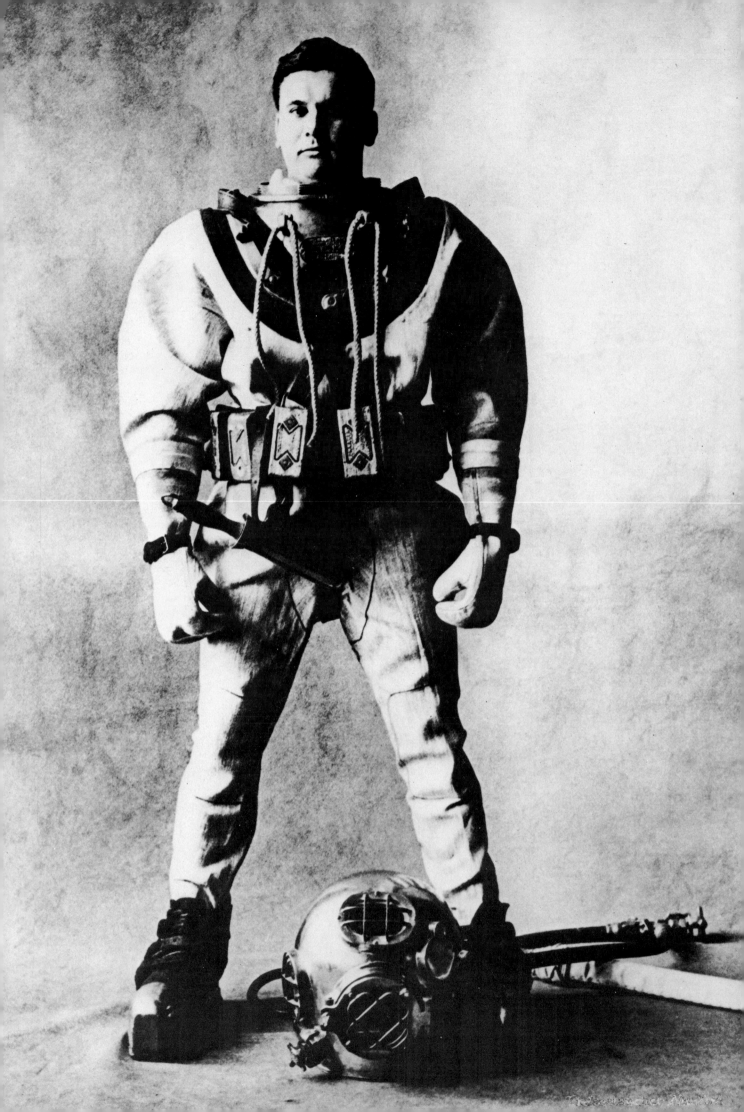

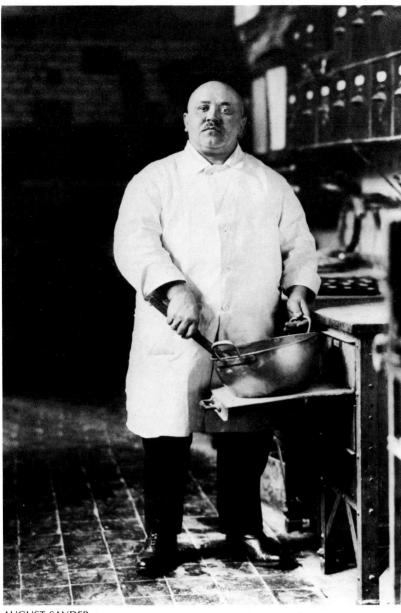

AUGUST SANDER

What a person does is one of our main curiosities about them. Usually, the right clothes and the tools of the trade are all the clues one needs to provide. If the subject can be shown at the point of work, so much the better. August Sander's portrait of a pastrycook shows the style, an informal setting but a formal picture.

Sander was not concerned with creating an effect but with precise, objective documentation. The approach is simple and direct. The pose is explanatory but rigid. The expression is dignified but frozen. The light is even and the subject stands out clearly against the background but without undue drama. There is no sense of relationship between subject and photographer. The man is being catalogued.

Irving Penn's portrait of a diver is, at first glance, even simpler but is actually more sophisticated. The photographer is consciously producing a striking and attractive image. The setting may be plain but it is also surprising for such a subject. The pose and the equipment have been carefully arranged. Above all, the lighting is superbly controlled and dramatic. The raw candour of the Sander picture has been replaced by charm.

Arnold Newman's portraits are sometimes described as environmental. In other words, the subject is photographed in a setting that reveals his occupation. The best of his work, however, goes far beyond such superficial relationships. Background details become not merely descriptive but symbolic. This is perfectly illustrated in the Stravinsky portrait. The assertive black shape is read not just as the lid of a piano but as a gigantic musical note.

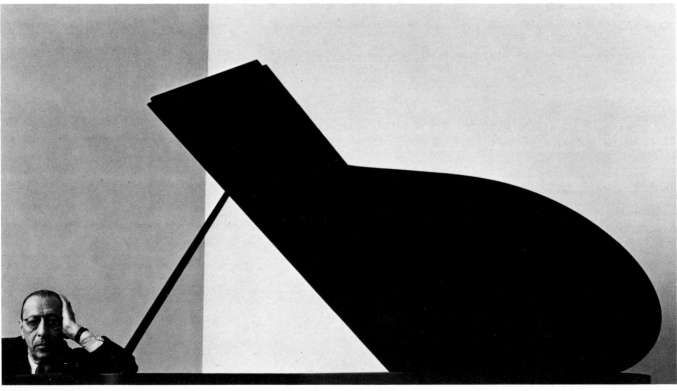

ARNOLD NEWMAN

These portraits were all taken on the wing. They are spontaneous records and not the results of set-up situations.

The precision and complexity of visual judgement that a great photographer can make instinctively in a fraction of a second is almost incredible. The picture by Henri Cartier-Bresson is a classic example. Its narrative content is minimal. Nothing special seems to be happening, just an old Chinaman with a curious, pixie-like face walking by in a Peking street. But visually it is so rich in detail and composition. The various elements of shape and tone interrelate with such a satisfying balance. Look at the way the shadow of the secondary figure has been caught exactly at the moment it blends most harmoniously with the background shadow. And the figure itself, almost in silhouette, echoes its own shadow.

In contrast, the strength of the photograph by Constantine Manos is in its pure simplicity. Face and hand: grief and comfort. The minimum of detail, for the maximum of effect.

The elegant wit of Elliott Erwitt is one of photography's most refreshing pleasures. Analysing humour is about as productive as trying to plug holes by firing bullets into them. But again, one can at least admire the economy of means and the compositional flair. How tightly the picture is cropped and where, is basic to its success.

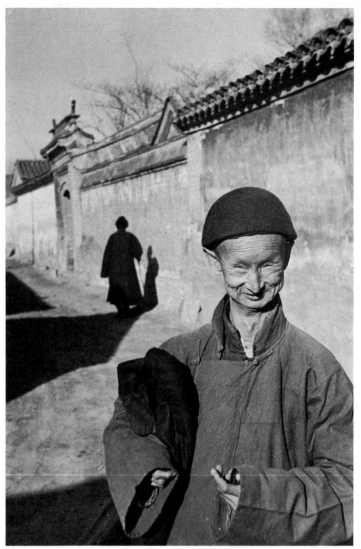

HENRI CARTIER-BRESSON

12

ELLIOTT ERWITT

1 LEONARD FREED

2 DOROTHEA LANGE

3 ALFRED STIEGLITZ

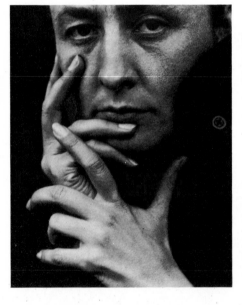

4 GEORGE PLATT LYNES

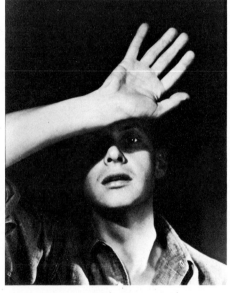

5 GEORGE PLATT LYNES

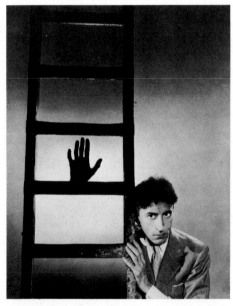

6 DAVID OCTAVIUS HILL

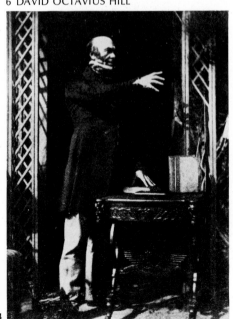

7 CECIL BEATON

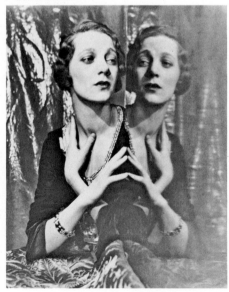

8 FREDERICK EVANS

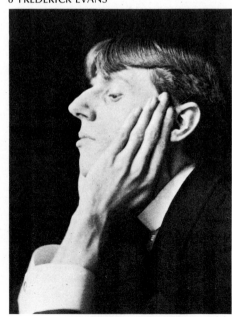

Hands present a serious problem in formal portraiture – that is, once the photographer decides to pose them. Usually the challenge is studiously avoided. A head and shoulders view crops the arms off altogether. In more full-length portraits, the arms are often just left hanging at the sides, or perhaps with the hands lightly clasped in front of the body. One must have seen it a thousand times.

At one time there was a vogue for men to be photographed with one hand tucked well inside their coats, very Napoleonic. At least that halved the problem.

It is really very difficult to pose hands so that they look attractive, contribute to the overall shape of the picture and yet seem quite naturally placed. Once one tries to move beyond very basic positions, the results are nearly always conspicuously mannered.

Less self-consciousness is involved with informal portraiture and people can be seen expressing themselves through more normal gestures.

Today, the best formal portraits have elements of informality that make them more credible images. The contrived pose is very suspect and the trend is towards a more direct and simple approach.

The pictures opposite show a variety of ways in which, over the years, photographers have made a determined use of hands in portraiture.

Two of them are especially interesting. The George Platt Lynes' portrait in the centre of the centre row, its subject being a very young Henri Cartier-Bresson. And D.O. Hill's portrait of Dr Knox, bottom left, because of the brave attempt to express gesture. It was taken in the mid-19th century, the exposure would have been very long and so the doctor's outstretched arm is discreetly supported by a thread, later retouched from the negative.

SIR BENJAMIN STONE

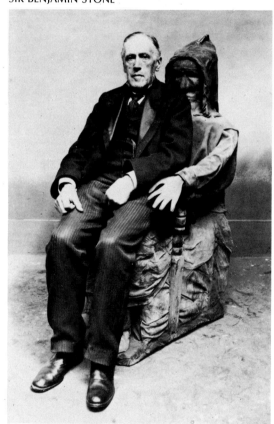

AUGUST SANDER

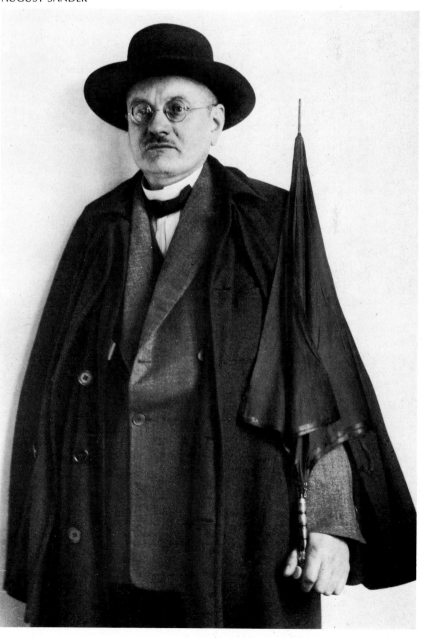

Props can do anything for a portrait, from creating their own excitement, to soothing the nervous sitter. The grotesque chair in the photograph by Sir Benjamin Stone was a great find. It makes the picture. You might even say that the man is the prop and the chair is the subject.

August Sander was usually content to take advantage of quite discreet accessories. The up-tilted umbrella is such a simple but clever touch. It's easy to forget that one's clothes are props in themselves. The most ordinary hat has helped to work visual miracles.

15

There is a tendency to think of composition simply as the arrangement of elements within a space. But those elements also relate to the boundaries of the space itself, to the image format.

This relationship is often a rather passive one, the outside frame merely describing the general background area and giving proportion to the picture. But it can function much more actively, creating distinct visual tensions between the contents of the image and the line that contains them. This is sometimes called 'the cutting edge' and it does suggest the keenness of decision between what it includes and what it excludes.

The immediate impact of Burt Glinn's colour portrait, right, is largely due to how tightly it is cropped. This dramatic effect is reinforced by the striking make-up. It is interesting to experiment how closely one can crop a face before it starts to become anonymous.

The precise use of the cutting edge is very obvious in Bill Brandt's picture of Joan Miró. The legs are truncated just below knee level and any more detail would simply spoil the balance and excitement of the shape. Even more conspicuously, the picture frame slices through the artist's head and body, attracting the reader's attention despite the competitive graphic force of the painting. Suddenly one notices how Miró's work itself is cropped and the surprise is complete.

BILL BRANDT

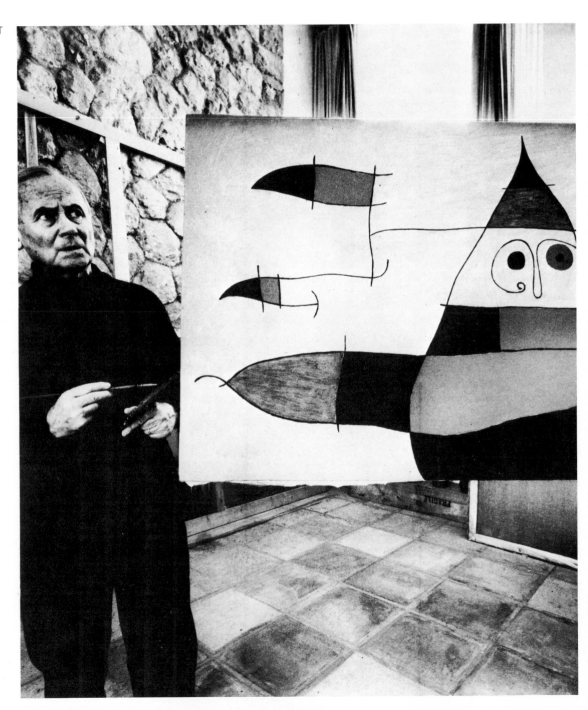

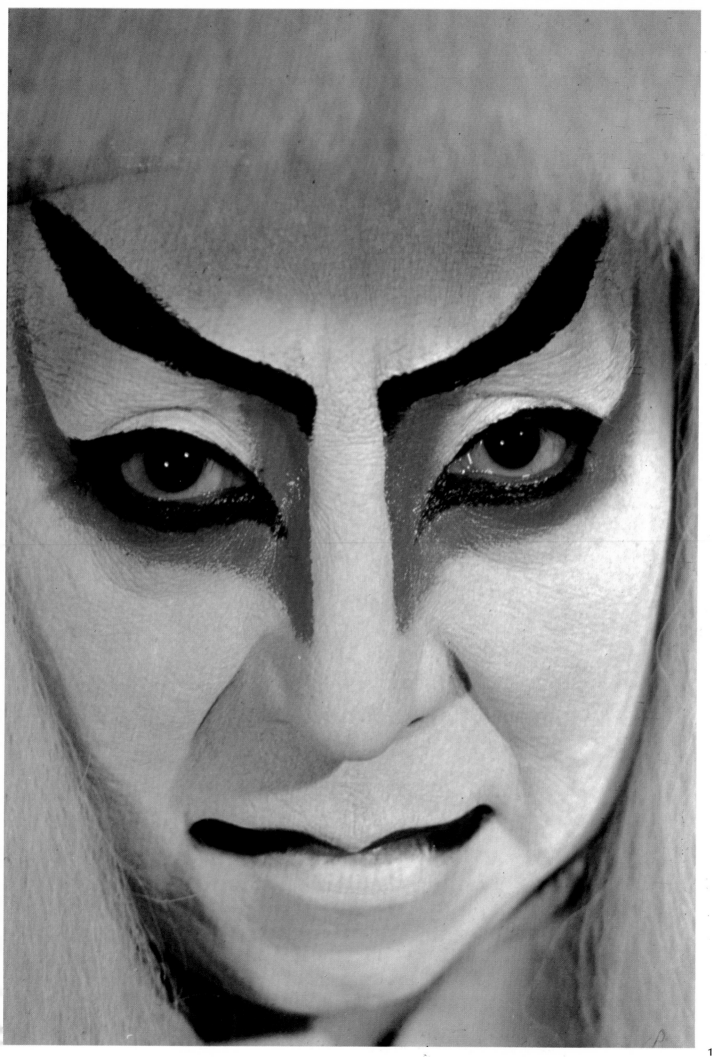

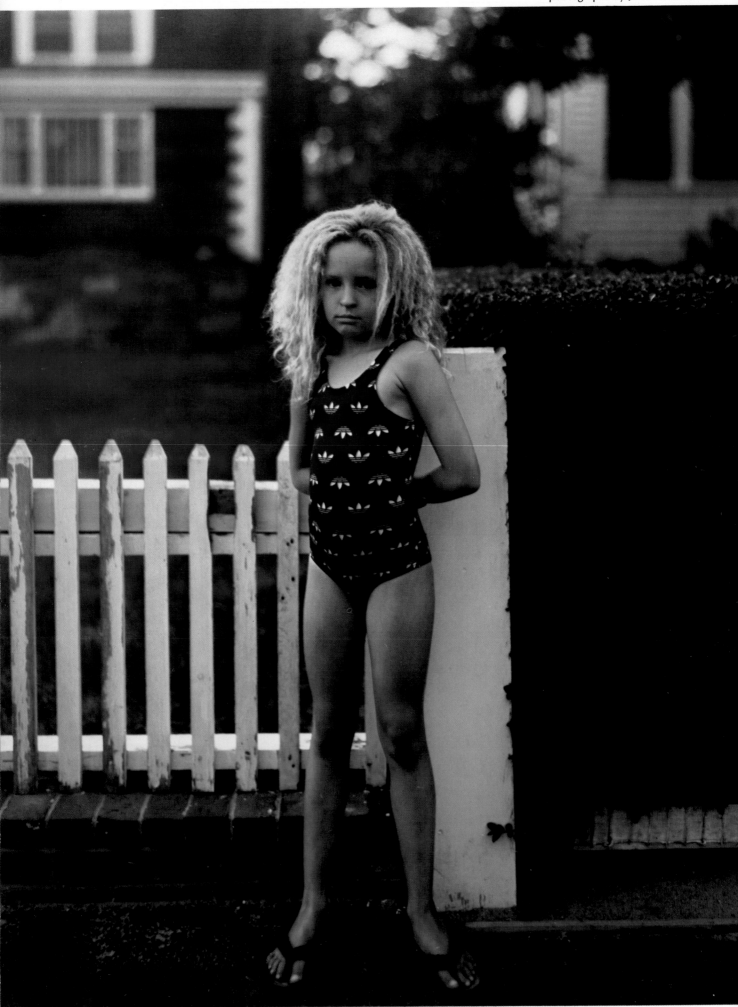

photographs by JOEL MEYEROWITZ

Joel Meyerowitz's first enthusiasm in photography was recording the street life of his native New York (see Chapter 5). His 35mm camera with wide-angle lens has since been replaced by a 10×8in. camera, and his choice of subject and approach is also very different. But he is still prepared to use this formidable, bulky apparatus to seize images that suddenly offer themselves for a brief moment.

The portrait on the left is a good example. He was about to pack up for the day after a session of urban landscape work, when this young girl came up to watch. He was struck by her combination of innocence and incipient sensuousness, told her not to move and quickly adjusted the camera. The light was failing and so he had to use a very wide aperture to keep the exposure as short as possible and reduce the risk of the child moving. That explains why the background falls out of focus so quickly.

In the other portrait, again impromptu, it was most important that the background be sharp. Since depth of field is so shallow with a large-format camera, the lens had to be stopped well down. The exposure was

very long but, in a comfortable position, the girl was able to keep still.

There is so little colour in the portrait overleaf by Eve Arnold but what there is, absolutely makes the picture.

The intense brightness of the eyes is remarkable, especially against the dark tones of the face, clothes and background, but it is the touches of green that create such a memorable image. They bring an extra emphasis to the obvious focal point of interest.

The strength and the danger of colour is that it can dominate an image so easily, overriding any other priority, visual or narrative. The photographer has to be very wary of its assertiveness. In this case it all works together beautifully.

The framing of the face against the black robes is also effective. The result is so pronounced because the exposure was calculated for the lighter areas and therefore very little detail is visible in the darker tones. If one concentrates hard on the outline of the face itself, it appears to stand out from the rest of the picture like a disembodied mask.

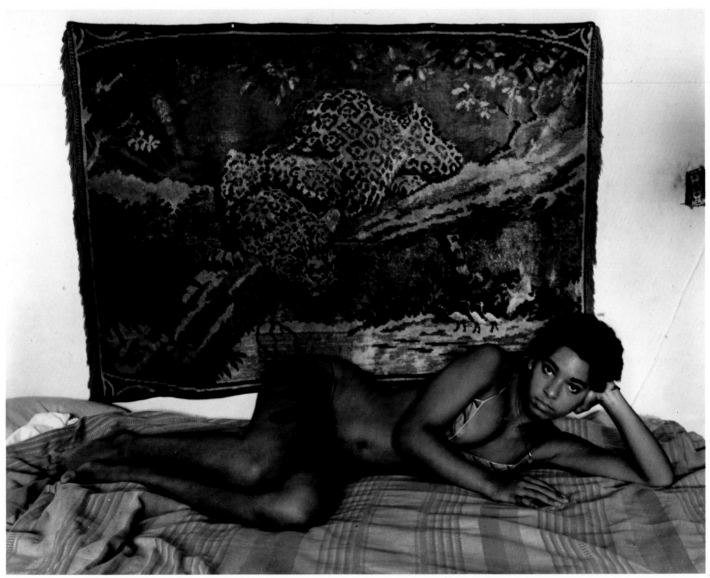

SHIRLEY BELJON

Facial expression has a high priority in most portraiture but sometimes it is irrelevant or even a distraction from the major interest. For instance, if one is preoccupied with certain considerations of shape. The results may not be portraits as one normally understands them. Features may be totally obscured. But they are still intriguing studies of the human head and just as valid as any more conventional approach.

The individual identity of Erich Hartmann's subject is not important and far from obvious. The photograph is principally concerned with the arrangement of forms, with shapes and volumes. We learn very little about the girl but we are entertained by the way three-dimensional objects are represented on a two-dimensional surface.

This picture and David Newell Smith's opening portrait are closer related than it might seem at first. They share a similar curiosity about the nature of the photographic image.

The tonal structure of Erich Hartmann's photograph helps to create the illusion of roundness and of depth. Quite the opposite is true in the Shirley Beljon picture. The high-contrast print emphasises the flatness of the image plane.

Shape is again the prime visual interest but of a more starkly graphic description. The severe trimming of the face across the eyes is very dramatic, as are the rather bizarre details of dress.

The photographer used this technique to express her strongest impression of the subject's personality. The decisions that shaped the image evolved naturally during the session. Above all, she wanted to convey some sense of this man's visual impact, to suggest the general reaction to his striking façade of eccentricity.

Even with maximum contrast, the first prints did not quite put over this extraordinary quality. She felt that the scale was wrong, so she enlarged the image even further and cropped it to emphasise the detail. Then she noticed the effect of truncating the face at eye-level and boldly went ahead.

ERICH HARTMANN

The photographic image is made up of a range of tones from black to white, with gradations of grey, or shades of colour, in between. By skilful lighting and exposure, the tonal balance of the finished picture can be controlled, making it as light or as dark as one wishes. At extreme ends of the scale, the effects are known as high key and low key.

A high key image, as below, is almost entirely composed of lighter tones. Detail is usually kept to a minimum but small intensely dark areas can be used very dramatically. In this Harry Callahan picture, the eyes are the obvious centre of attraction but it is interesting how he used shadow to outline the face and give it strength.

A low key image, as on the right, is just the reverse, with a preponderance of dark tones. This portrait by Dennis Stock shows what a suitable technique it is for capturing detail. Tonally it is such a rich picture, from the background black to the bright highlights on the earrings and mouth.

For the best results these techniques should be planned in advance. One cannot always rely just on darkroom magic.

HARRY CALLAHAN

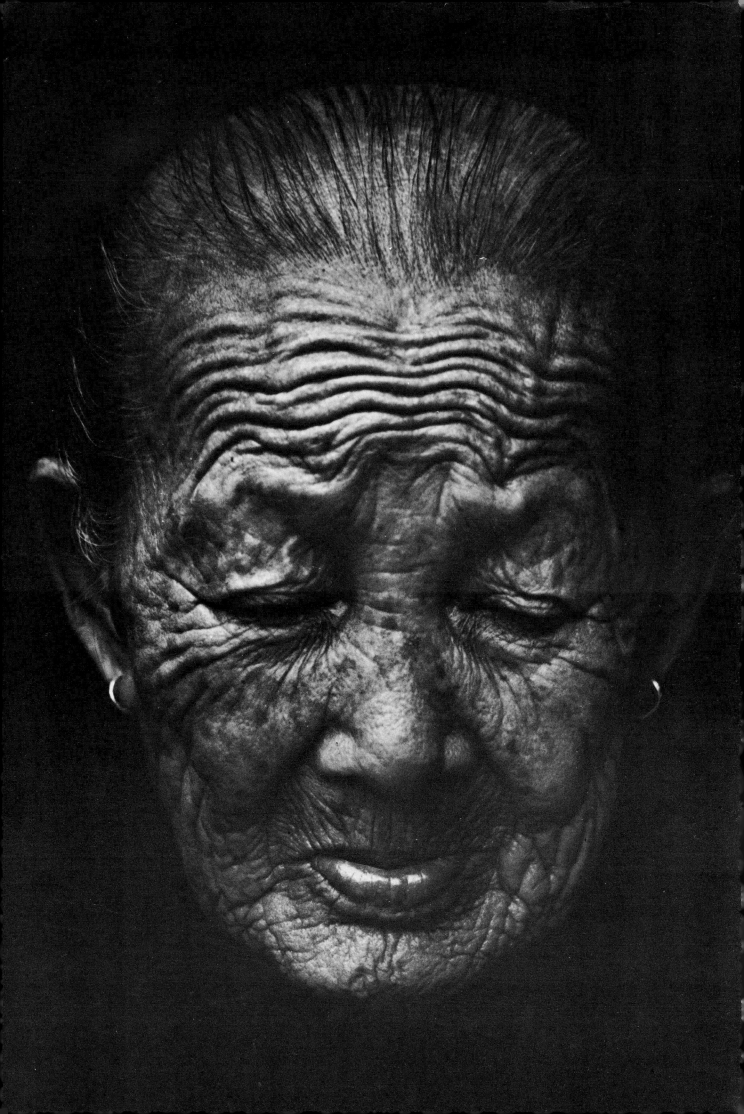

These pictures are of famous people but essentially they are as much about light as about personality. Brian Griffin's portrait of George Cole, right, is an unique combination of both. The photographer has used the very limitations of the photographic process to express light, as a means of commenting on the subject's personality and occupation.

George Cole's face is 'burned-out' because that area of the image is heavily overexposed in relation to the rest of the picture. The face is invisible even though,

or because, it is in the full glare of the light. We recognise the subject only by his reflected image, a not irrelevant observation about our awareness of actors.

Bill Brandt also makes use of basic photographic qualities in his portrait of Robert Graves. By printing for heightened contrast, highlight and shadow areas are both strengthened. The picture has more immediate graphic impact and the reader's attention is quickly drawn to the subject's eyes.

BILL BRANDT

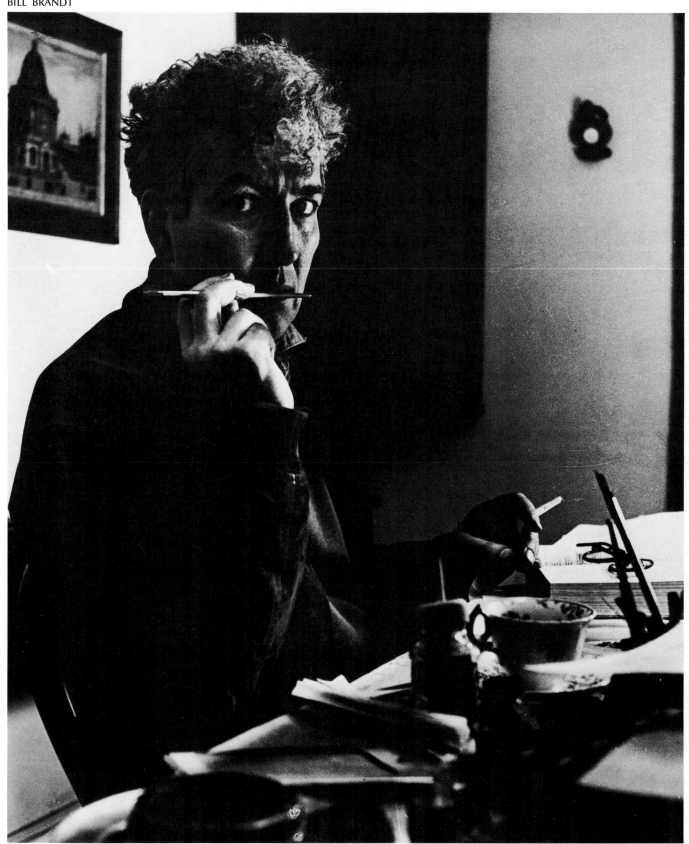

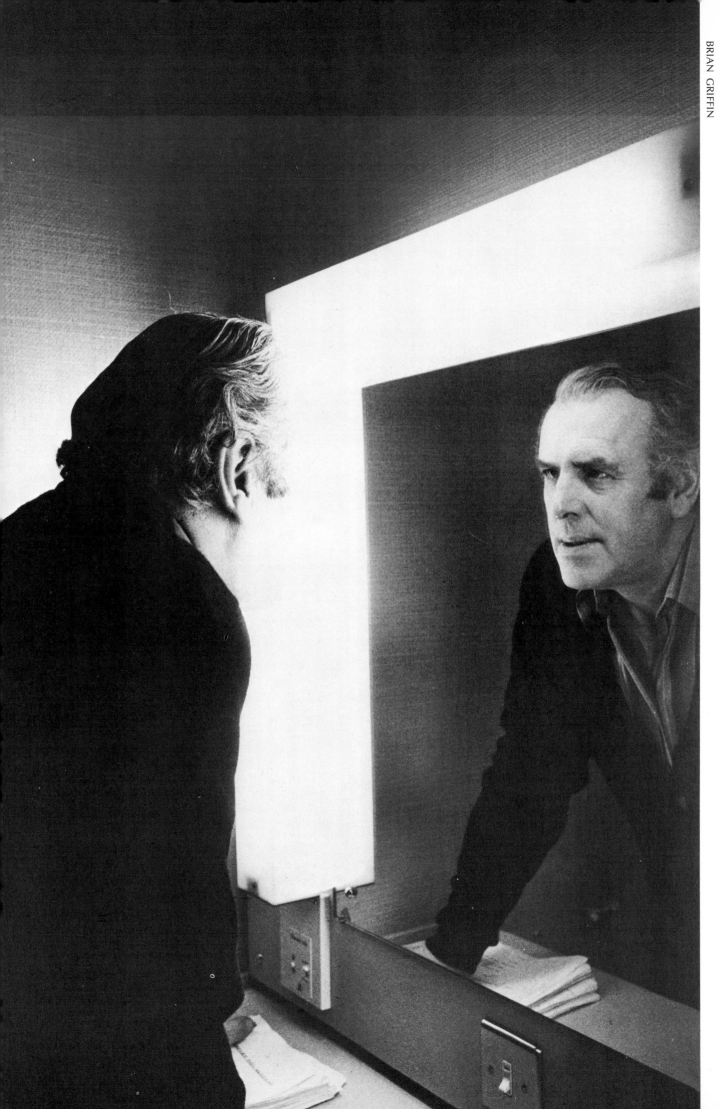

The most obvious advantage of using a wide-angle or a telephoto lens is that you can take in either more or less of your subject from the same camera position. But even more important, they give greater flexibility in controlling perspective. Change of focal length does not in itself alter perspective. That is brought about by a change of viewpoint. But it does affect the image size of the subject, making it either possible or even desirable to alter the camera/subject distance, thereby changing the perspective.

Arnold Newman's picture of David Ben-Gurion was taken with a wide-angle lens and typifies its usefulness in relating subject and environment. The foreground is crucial to the dramatic structure of the image but the background is also significant. The nearness of the camera and the angle of view create a powerful shape from the spread documents that is emphasised by the tonal contrast. The relatively disproportionate size of hands and body is acceptable because it is fundamental to the strength of the composition.

The distance from the camera to the subject's face is perhaps 3ft. The hands are almost twice as close and so seem much bigger in comparison. The angle at which the different planes of face and hands are observed, also contributes to the effect.

The situation is reversed in the telephoto lens portrait by Colin Jones. Details are compressed rather than extended. Notice how the cigarette is flattened into the face and how little illusion there is of depth.

Using a lens of just under ×4 magnification (180mm focal length on a 35mm camera), a head and shoulders image filled the frame at about 8ft. The frontal depth of the face and the length of the cigarette are a very small proportion of the camera/subject distance. Since the differences in depth between these details are relatively so insignificant, they appear to be almost on the same plane. As a result the pattern of facial features is very strongly emphasised.

It is not too difficult to previsualise the effect of a lens once one realises the importance of subject depth in proportion to camera/subject distance.

ARNOLD NEWMAN

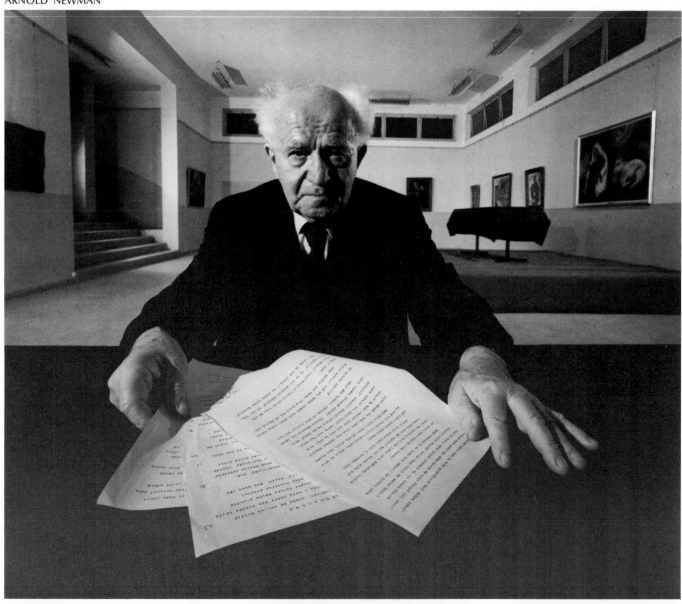

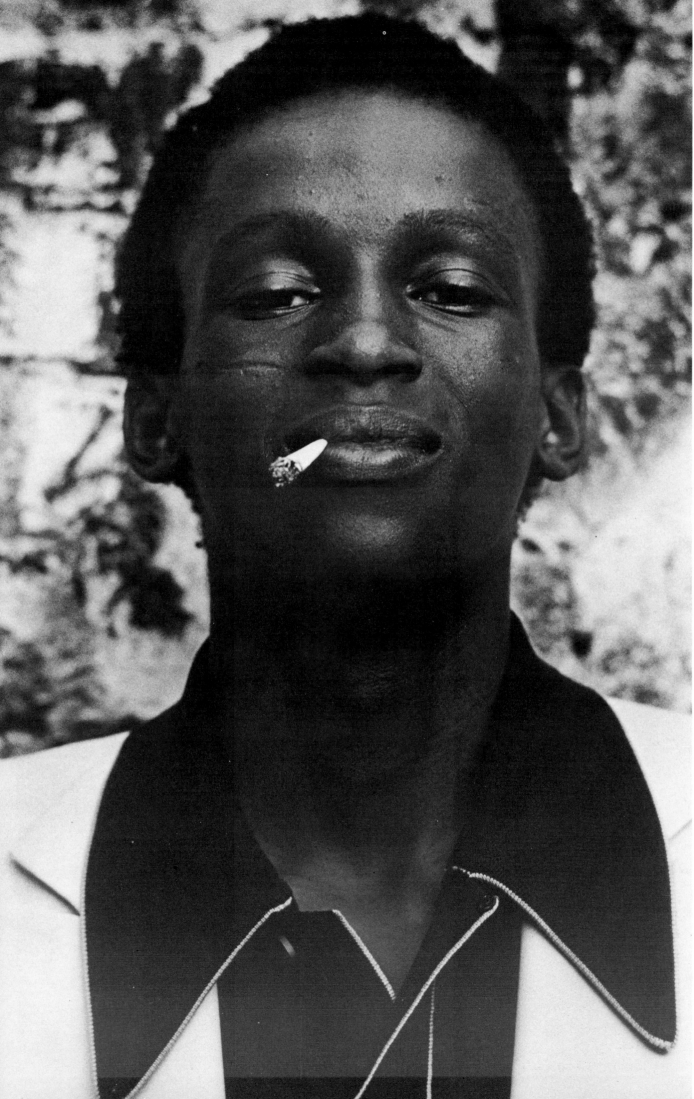

2 Landscape

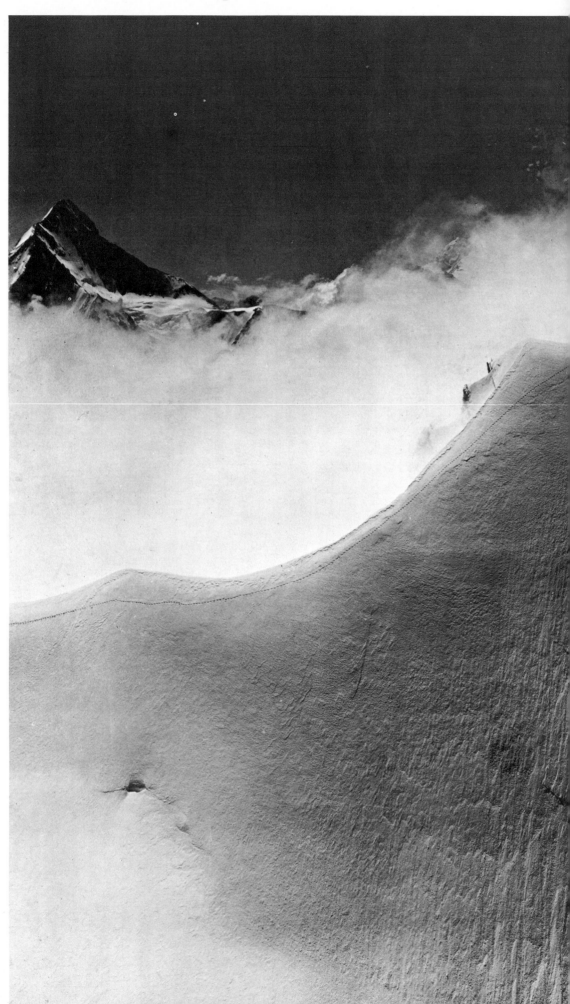

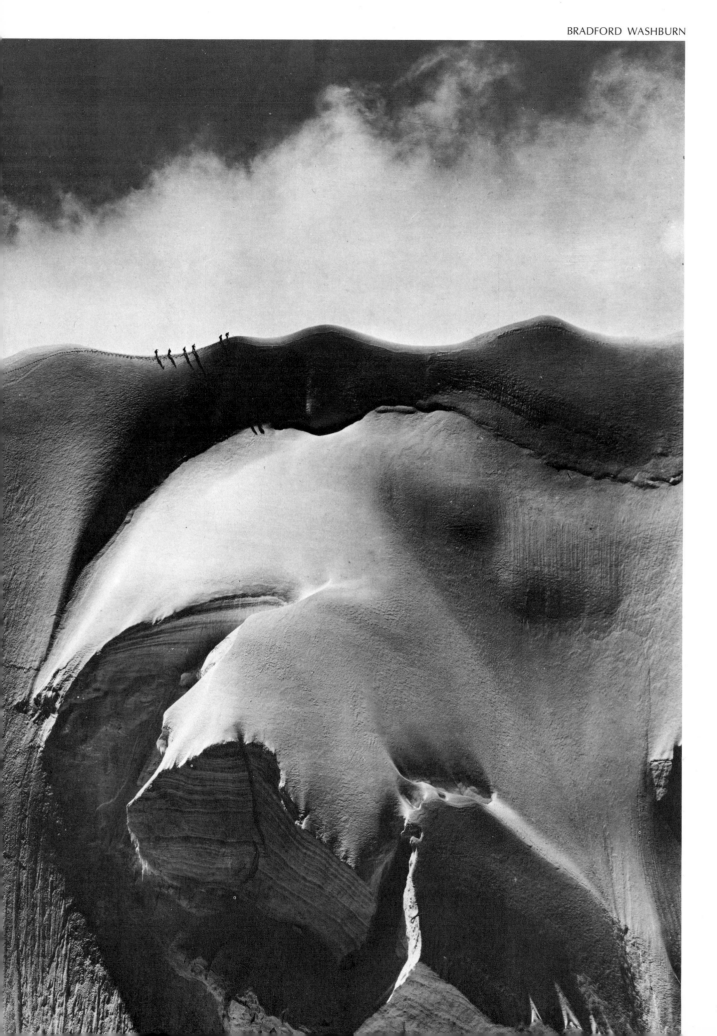

The landscape has always been a favourite photographic subject, for many obvious practical and aesthetic reasons. But how can one give any idea on a small sheet of photographic film or paper of the real nature and size of a landscape or communicate a convincing sense of space?

The truth of the matter is that at a superficial level, one doesn't have to try too hard. We take so much for granted. Our minds are attuned to the basic conventions of pictorial symbolism and our imaginations interpret photographic information in terms of visual reality. We accept grey as the colour of a field; we recognise that a figure one-eighth of an inch in size is a person; we instinctively understand differences of tone as degrees of depth.

Sometimes the evidence confuses us and we misread a situation. For example, when unusual perspective is involved, as with an aerial picture.

This should alert us to the fact that images are complex illusions and not just simple reflections of reality. We need to be able to understand some of the implications of what that involves, if we are to appreciate the lines of development of much contemporary photography.

Beyond the basic creative level, problems of size, proportion and scale are of critical interest. And there are other preoccupations – the description of natural energy at work in the landscape, the action of wind and water, the processes of growth and decay. There is more to be described than just a pretty view.

FAY GODWIN

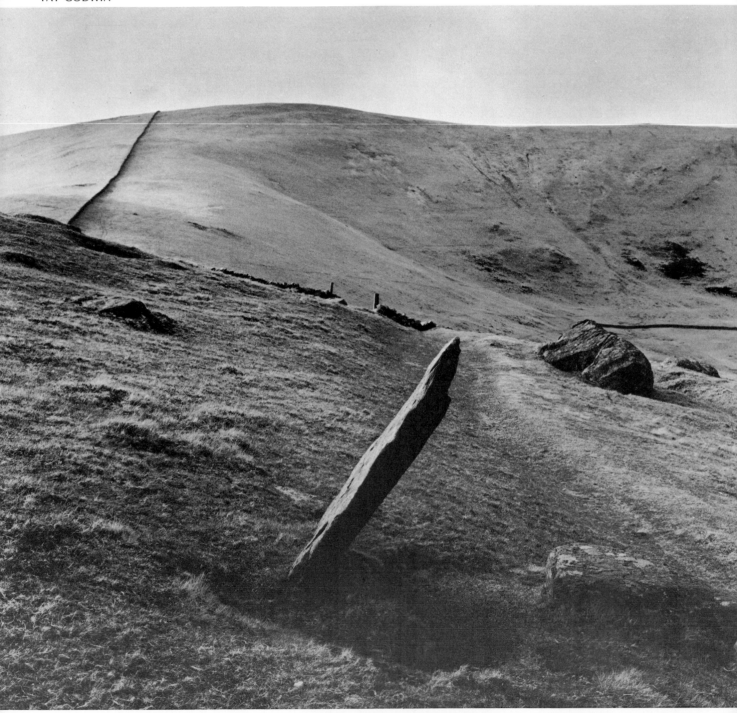

Bradford Washburn's opening photograph has been described as 'perhaps the finest of all mountain pictures'.

Look at two points in particular, the six tiny figures on the skyline, and the mountain surface. The climbers are just minute, black dots but they dominate the image. It is like watching a file of ants crawling over a nude – the eye cannot ignore them, whatever the competing attractions. They give the picture scale and a sense of the monumental that stimulates sensations of physical challenge and achievement.

The other fascination is how the image alternates between effects of depth and flatness. One moment the spatial illusion is total, then suddenly it becomes conspicuously two-dimensional, designs of tone on a flat surface, as indeed it is. To add to the confusion, sometimes areas seem to recede into the mountain rather than standing out from it.

The basic elements of photographic composition are line, tone and space. It is the skilful balance of these that gives a picture distinction.

Most photographs involve a good mix of the different factors but sometimes one clearly predominates. The work of some photographers is easily recognisable because of their consistent preference for a certain approach.

Bill Brandt's work has such a distinctive quality, as we have already seen. This land-

BILL BRANDT

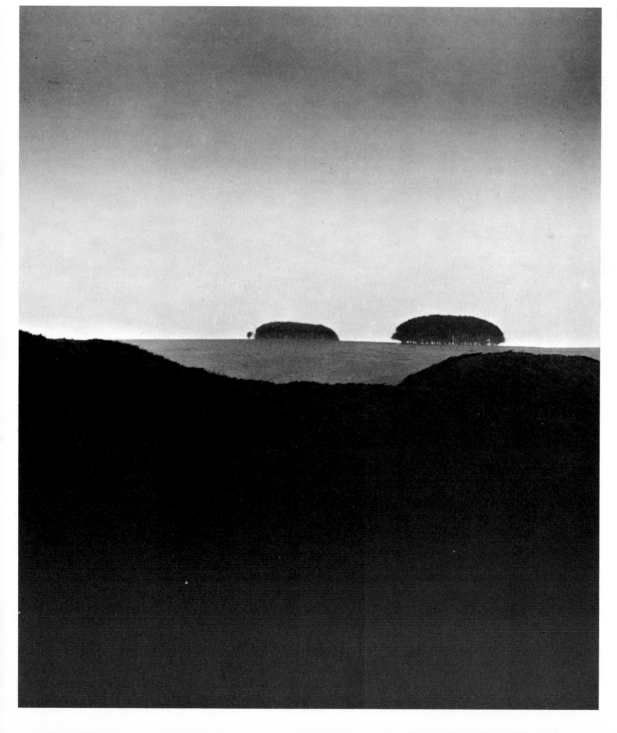

scape is another excellent example of the strong tonal structure of his images. The picture seems to exist on one plane, with no feeling of depth. It is an arrangement of areas of tone in relation to each other and to the picture space. Notice the balance of the image above and below the line of the horizon that bisects the frame.

The process of composition is sometimes intellectual but often, quite instinctive. One is not always certain precisely how a photographer arrived at a certain decision or even the extent of the decisions he made. Over-subtle interpretations of a picture and over-generous estimates of a photographer's intentions can be tedious. But one can often read and enjoy in an image some detail or illusion of which the photographer was almost certainly unaware. Hidden pleasures of this kind are to be expected in complex pictures. Also, as we become more visually aware, quite naturally we discover new excitements.

For example, one can sometimes read the Brandt landscape as though it does express depth and is not just a flat plane. The light grey field can be seen as though it is draped over the horizon like a sheet across

a line or like a tab ready to be pulled. A bit fanciful perhaps but once you are alert to the illusion it is clear enough.

In the Fay Godwin photograph it is the quality of line that catches the attention. It runs through the image, breaking-up some areas of space and relating to others. Notice how the edge of the rock in the foreground neatly divides the field in which it stands, then links up in a zig-zag design with the walls in the middle and far distance. And the tilt of the rock echoes the diagonal angle of the furthest wall. On the right of the picture another wall connects most elegantly to the overall design. Everything hangs together in a highly satisfying way.

Below, the photograph by Bob Kauders approaches the limit of pictorial ascetism. It is finely drawn and sparsely detailed, containing and describing space with the utmost economy. Some images demand greater enlargement than others and this picture certainly needs room to breathe.

It is interesting to compare it with the Brandt; the tonal extremes, solid black and open white.

BOB KAUDERS

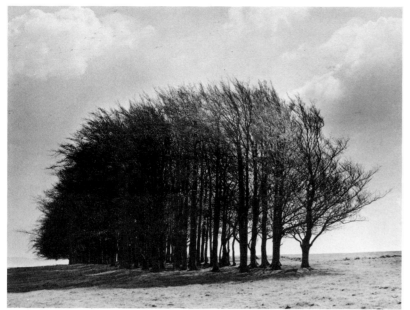

FAY GODWIN

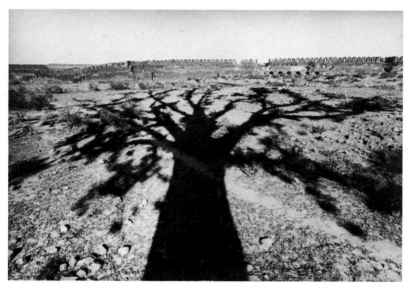

RENÉ BURRI

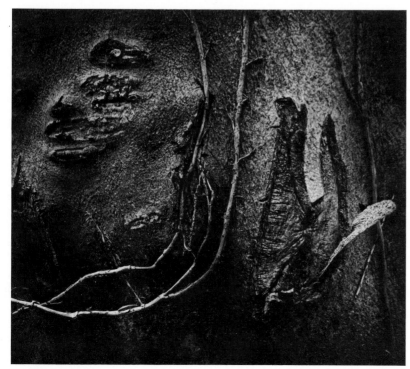

JOHN BLAKEMORE

The details of landscape are endlessly rich in photographic possibilities. And one can work at such different levels of scale, as is clear from these three pictures.

Fay Godwin's photograph is fascinating because it shows the trees both as individual objects and as almost indistinguishable elements within a collective mass. The transition from delicate tracery to almost solid tone is very curious and remarkably, the image is still unified within a distinct overall shape.

Looking at other people's pictures, it can be interesting to work out for oneself the value of certain judgements. For instance, if one crops the picture any tighter around the trees, especially in the sky area, does it help or harm the image and why? Would you agree that the expanse of sky is essential to the balance of the composition and also to communicate an almost indefinable sense of how the subject is set in space? Cover the top of the picture and see what it loses, both in proportions and atmosphere – no pun intended.

From a grove of trees to a single tree, or more accurately the shadow of one. René Burri is not a specialist landscape photographer but would be described more generally as a famed photo-journalist. Like most such labels, this too is alternately useful and confusing. Sometimes today there is a prejudicial implication in tagging someone as a photo-journalist, a suggestion of a narrowness of visual interest or sensitivity. Many of Burri's pictures, such as this one, indicate his personal range and show the difficulty of trying to define individual talent under comprehensive headings.

The image is an intriguing one, with various subtleties of interrelated tone, shape and texture. For instance, the shadow is not solid black but reveals underlying details that acquire a confusion of identity. They are included within the tree-like shape and simultaneously seem like tree markings but conspicuously are not.

In John Blakemore's picture the detail is real enough. We have moved even further from the general to the particular. Superficially it is a study in the action of light within a composition of markings in the bark of a tree and lines of creeper. But it implies a deeper significance and indeed communicates at a more instinctively superstitious level. Without needing to be more specific in expressing what can only be subjective reactions to this image, it is obviously capable of disquieting the reader and even perhaps of evoking subconscious feelings about the essential mystery of natural forces.

John Blakemore's photography springs out of an obsession with such concepts.

GIANNI BERENGO-GARDIN

RAYMOND MOORE

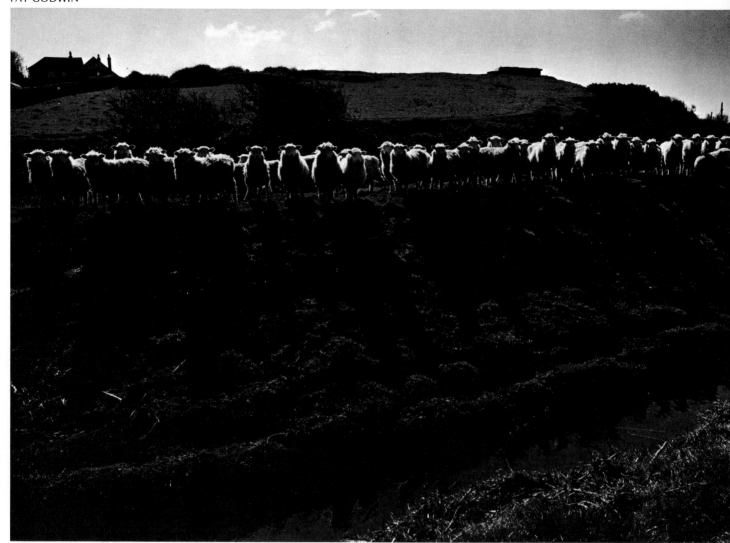

People and animals have obvious and close relationships with landscape that can be expressed through photography. They may also be used to give scale, as can be seen in the opening picture of this chapter and also in the photograph by Gianni Berengo-Gardin, top left. This also shows how they introduce movement to a rather static subject and how important their relatively small shapes can be within the broad sweep of a composition.

Notice how the horse is caught precisely between the diverging lines of the ploughed strips and attracts the eye by the liveliness of its form and its darkness of tone. The figure of the man in front is tiny and delicate but it is similarly crucial to the design. Without these elements the image would have so much less vitality and interest.

Animal shapes provide the basic excitement in Fay Godwin's picture but it is the light that works the magic. There is an immediate dramatic impact but the detail is attractive and even amusing – the rim-lit sheeps' ears, for instance.

The photograph, from a series on Romney Marsh, is composed in bands of tone, the visually busy line of animals with its fragmented highlights, balanced by the weight of darker greys. Fay Godwin carefully preserved the subtle tonal gradations in a subject so much on the brink of extreme contrasts.

Raymond Moore's photograph makes an almost soothing first impression. The eye is so relaxed by the soft light, the delicate textures and the expanse of flat, restful grey, that one is suddenly surprised to realise that the foreground is not a sand dune or similar landscape feature but the back and mane of a horse.

It is so cleverly done, the figure neatly cropped and then smoothly blended into the background. The back-lighting again creates a significant, though far less aggressive, effect.

'Mood' is a difficult quality to describe or analyse but in Bill Brandt's pictures, so redolent of this factor, it seems to spring from an acute awareness of the effect of light on the subject and how this basic image can be dramatised through the black and white photographic process. Brandt makes bold use of contrast but he is also sensitive to the mellow varieties of tone at the darker end of the grey scale. This is more apparent in the earlier rather than the recent publication of his work.

An added surprise in this picture is the shadow across the moon. It is not an eclipse, Brandt says, but a phenomenon he has only seen on two or three other occasions.

BILL BRANDT

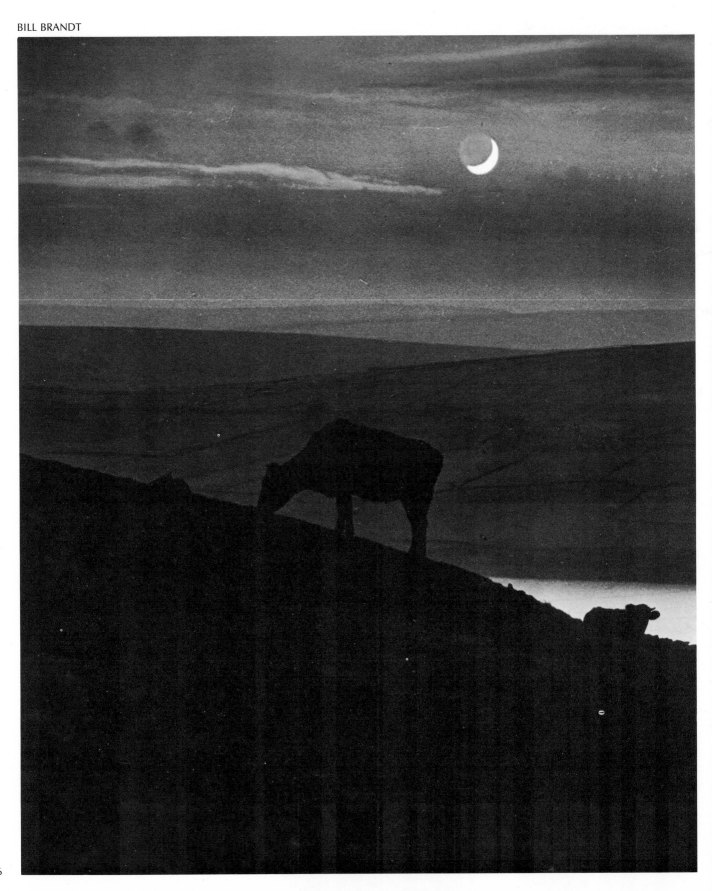

The contrast of light and shadow is also central to this photograph by André Martin. Colour has been used very sparingly, almost as a duotone rinse for the most part, and with white as the brightest tint.

Martin's approach to landscape is decidedly romantic but he uses techniques that are essentially photographic rather than painterly. Long focal length lenses allow him to compress areas of colour – notice how closely packed the trees are in this picture – and to explore the possibilities of different degrees of sharp and soft focus.

The shallow depth of field of a long focal length lens can have a significant effect over the distances involved in landscape work. The camera to subject distance, the angle of the camera in relation to the subject, the relationship of foreground or background to subject, the precise point of focus and the lens aperture, all can have a marked influence on results.

Martin's book 'Images d'une France' is perhaps not easily available except in France but it is worth looking out for, as an example of a very individual direction in landscape photography. It was published in 1977 by Delpire/'Nouvel Observateur'.

Ernst Haas is one of the major figures of colour photography and his work in this medium has an exceptional, one could even say unsurpassed, breadth. He has been greatly involved over many years in photographing landscape and Nature in general. The four pictures overleaf, concentrate on individual elements of landscape – fire, snow, cloud and water. Strangely enough, the first and the last were both taken at Surtsey, near Iceland, in the very year this volcanic island was born. The crater photograph was shot around sunset, so that there was enough light to reveal the background colour but it was sufficiently dark to bring out the full redness of the lava. The picture of the sea is sharp enough to show the pattern of the spray but not so sharp that the movement seems frozen.

Haas rarely uses filters but he does find that a polarising filter helps to tone down the bright blue of a sky and also creates a greater contrast with the clouds.

Snow covering the stones in a river bed echoes the shape of human forms. Such interrelationships are a constant theme in photography.

ANDRÉ MARTIN

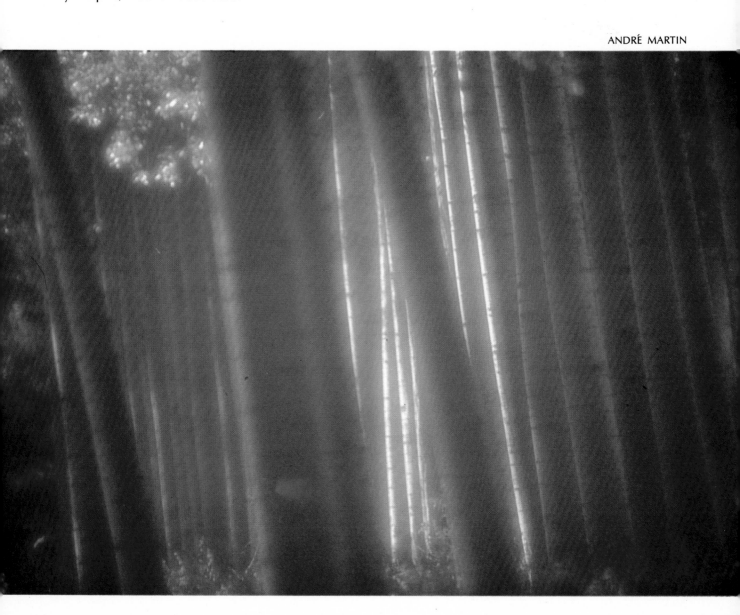

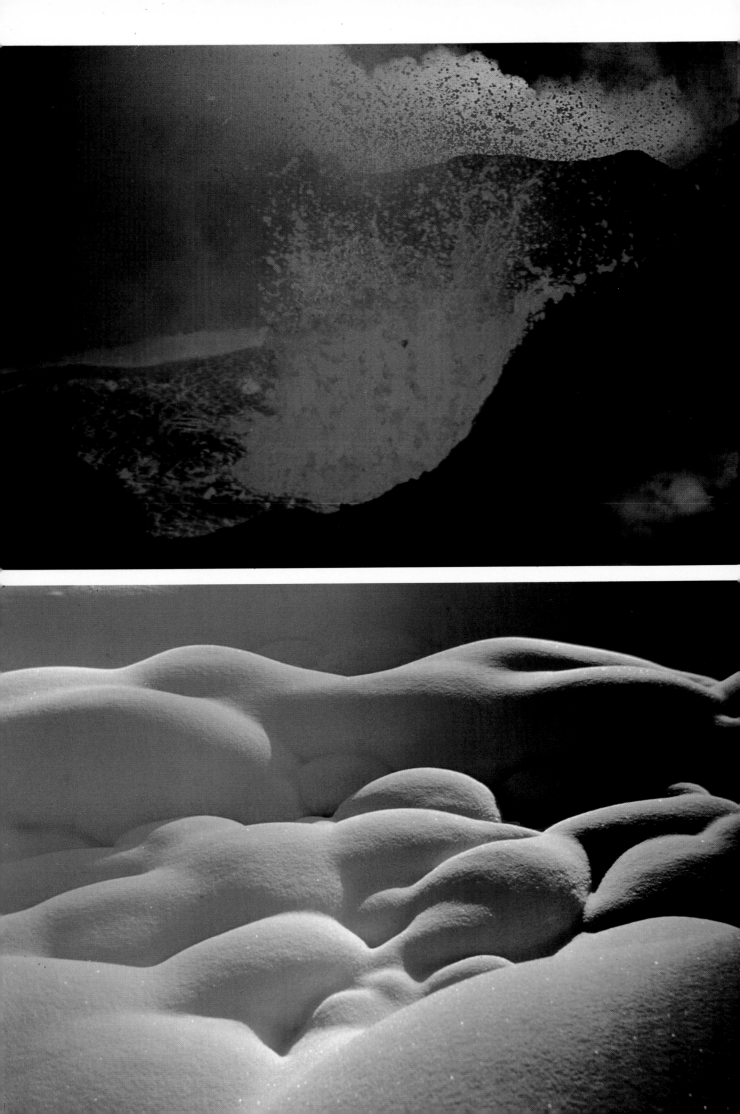

Photographs by ERNST HAAS

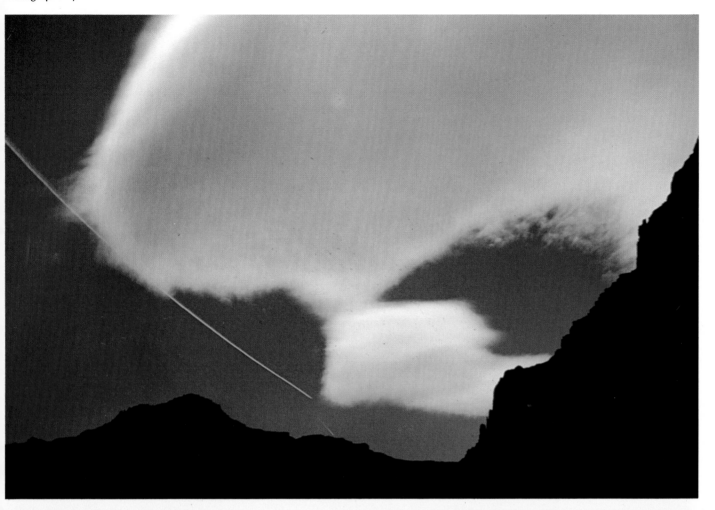

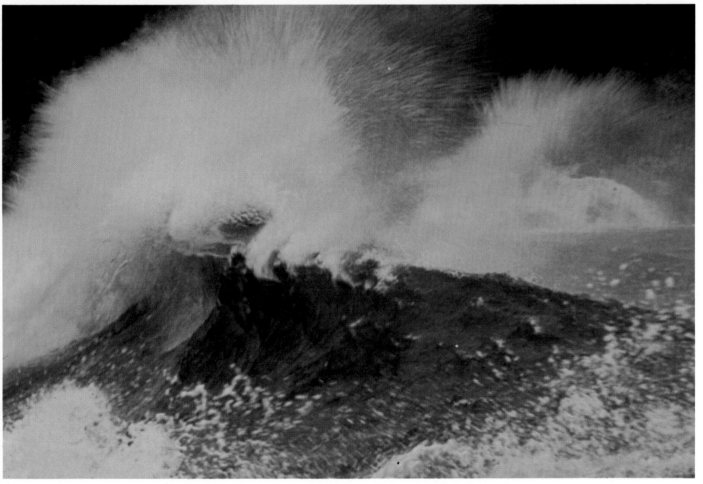

Colour gives added scope for the exploration of pattern and form. André Martin shows an area of delicate contrasts between broad, horizontal bands of subtle tints and fine, vertical tracery of detail. The photograph has the flattened perspective mentioned earlier as characteristic of the use of long focal length lenses.

The appeal of the Eliot Porter picture is immediate but it takes a few moments to be quite certain about its content. The channels are small stream erosions but the scale is not obvious at first glance. The eye scans the image for reassuring information and in the process discovers all manner of pleasures. The search for clues to the nominal subject leads to an appreciation of the actual subject – colour, texture and shape.

ELIOT PORTER

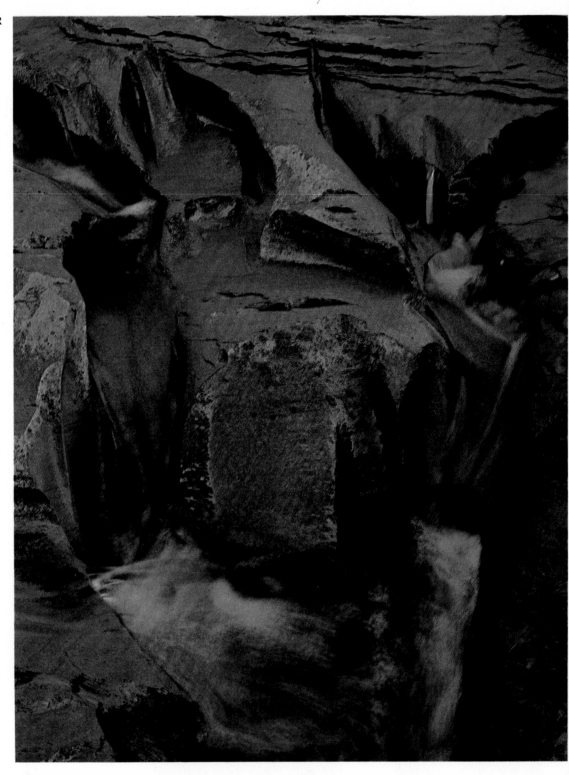

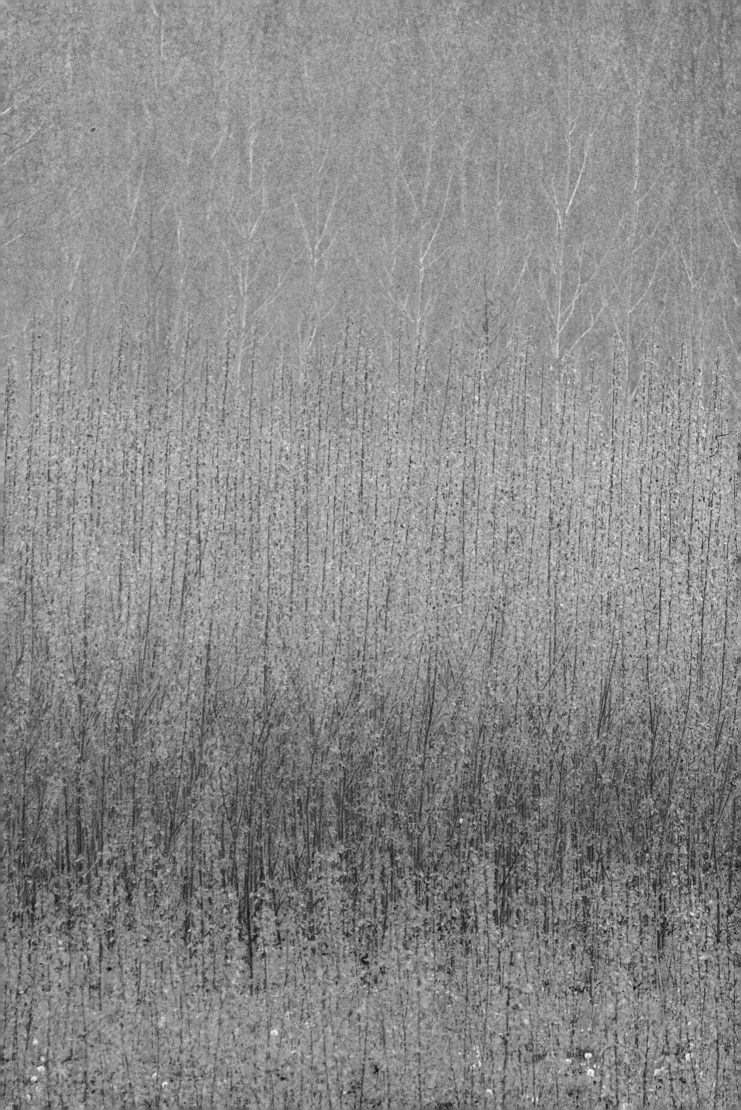

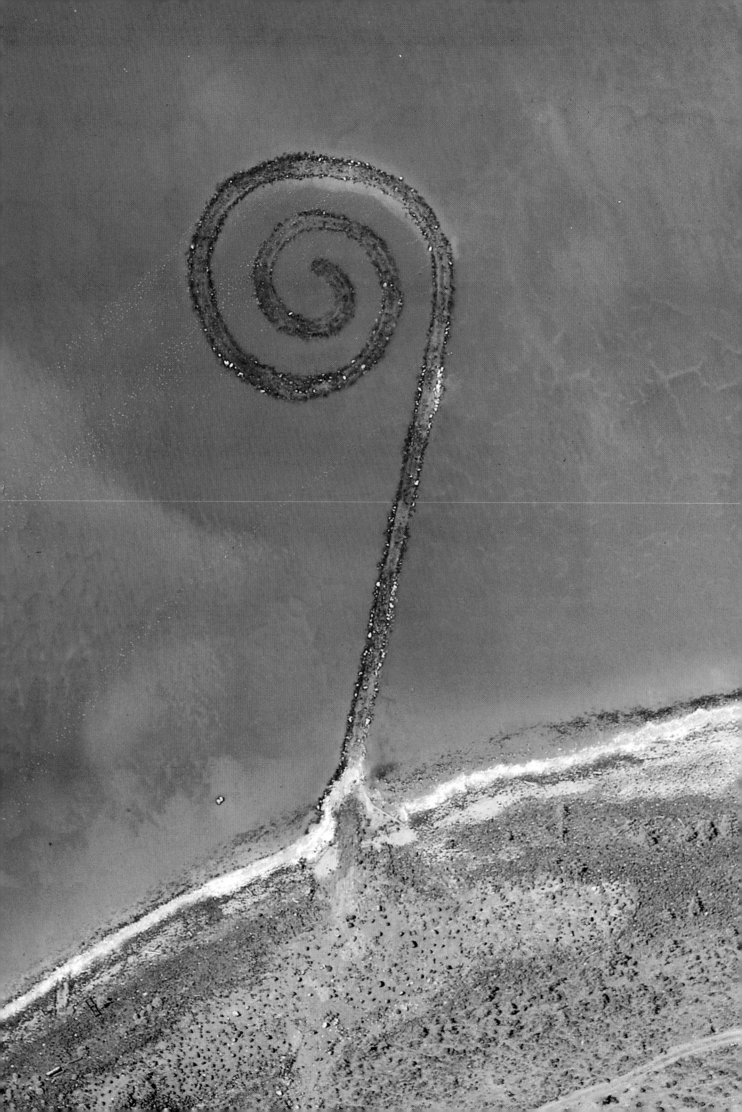

Aerial photography has provided a totally new experience in the images of landscape. Air travel itself has given many of us the excitement of a fresh look at the world. Looking down at fields, trees, fences and streams, we could not fail to notice bold, two-dimensional patterns of colour and form. Earlier, if we had seen images of such designs, we would have thought of them as abstract.

Georg Gerster is one of the most famous aerial photographers, with several remarkable books to his credit. This picture illustrates his flair for isolating fascinating detail, in this case an example of Earth Art, 'Spiral Jetty' by Robert Smithson.

In direct contrast, Raymond Moore's picture of a rock-face is absolutely packed with detail. Shapes within shapes within shapes. An extravagance of eccentric geometry. It is a superb example of photographic description, of the camera's unequalled ability to reveal and express information that simply overwhelms the eye. But one can study the image at leisure and enjoy its intricacies.

A rollfilm or even larger format camera is often preferable for such a subject. A big image makes it that much easier to record fine detail and full tonal gradation. But even if not directly comparable, 35mm can give surprisingly good results if used with care. This is especially true in colour, since one of the best emulsions is only available in the miniature size.

RAYMOND MOORE

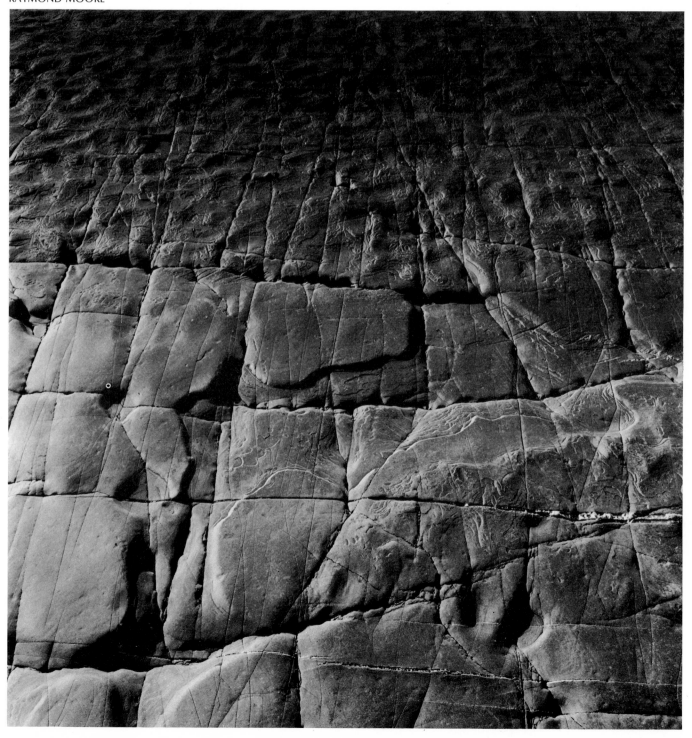

Broad sweeps of pattern are the keynote of these photographs and nowhere is it more obvious than in the Mario Giacomelli picture. The field is marked out like a contour map, the lines assaulting the eye with the bold, repetitive regularity of Op-Art. The inherently striking design is exaggerated by the print contrast, which also increases the suggestion of harsh sunlight. The overall dramatic graphic quality is characteristic of Giacomelli's work.

A feeling of strong light also pervades the landscape by Paul Nash but it creates more subtle effects across the coarse texture of the ploughed earth. The ridges and furrows are defined in highlight and shadow.

The direction of the light relative to the angle of the ruts has produced particularly interesting gradation in the middle and far distance. Compare the detail from left to right at the top of the picture.

The simple changes in the lines of ploughing impose the general image pattern but it is the quality of light that offers the real excitement.

The cool elegance of the Giorgio Lotti photograph is another fine pleasure. The areas of contrasting texture are relatively large and clearly separate but the detailed markings are delicate and curious.

Although the tonal gradation is both gentle and wide, with a solid black at one end of the scale, the highlights are muted and climax in a light grey not a bright white. This understatement pitches the mood of the image at a calm, reflective level.

GIORGIO LOTTI

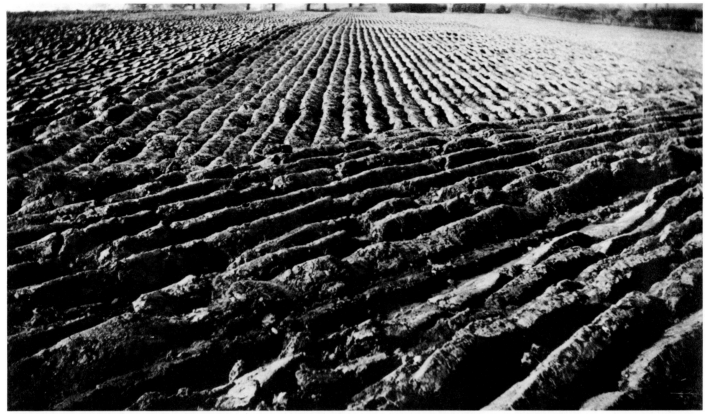

PAUL NASH

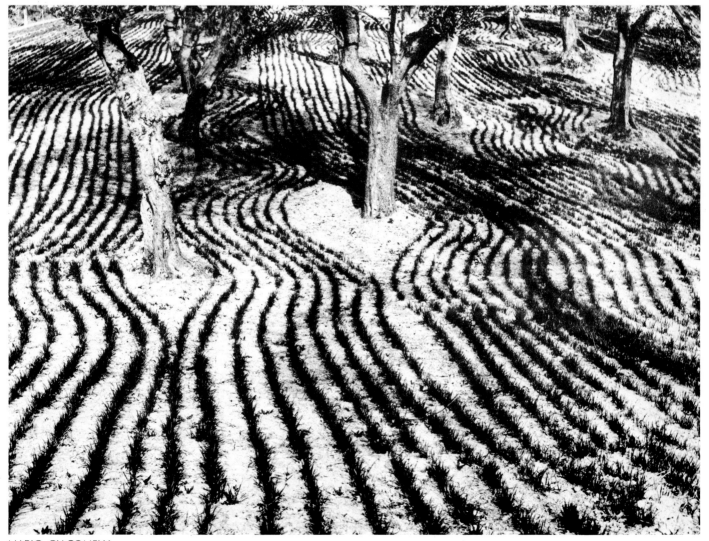

MARIO GIACOMELLI

Photographs by JOHN BLAKEMORE

John Blakemore thinks of himself as a photographer *in* landscape rather than *of* landscape. He is preoccupied not with describing the physical appearance of a scene but in expressing ideas through symbols discovered in the natural world.

'My interest is in the symbolic meaning which I can produce in photographs. The black and white image seems to produce this much more powerfully than the colour picture, which somehow seems too close to the actuality one is photographing. The black and white in some way separates one from the reality, it creates a different sort of experience.'

The theme of energy in landscape is one of the most important ideas in his work at the moment. In these three photographs he explores alternative ways of expressing a simple demonstration of natural energy, the movement of water.

They were taken in a small Derbyshire stream where he has returned to work

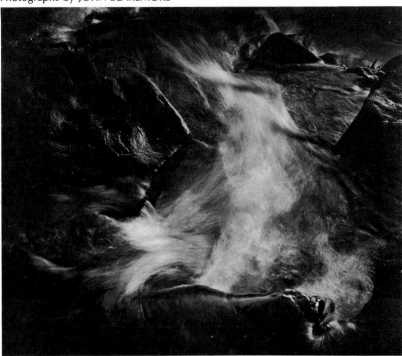

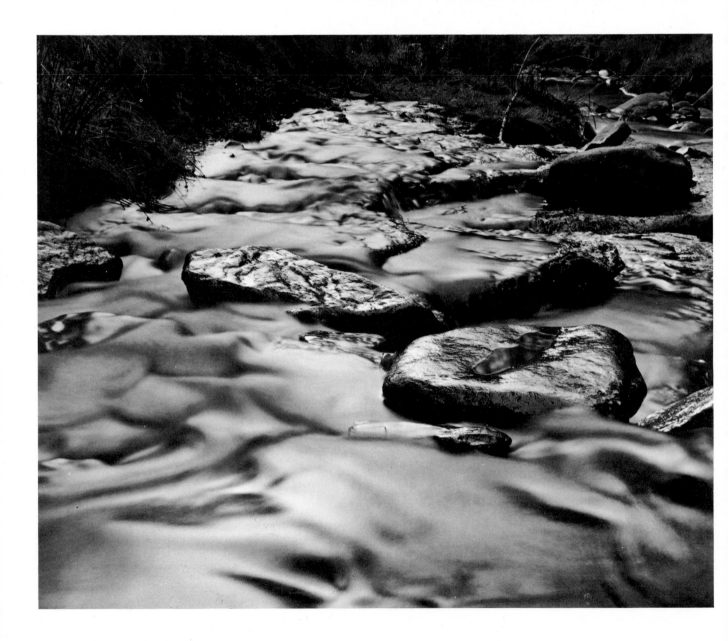

time after time over the last eight years, in all kinds of weather. And he has still only walked along a very small length of it. It is important to him to become familiar with a place. He explains why:

'I have a feeling that photography can be very superficial. One can lift up a camera and make a picture in a fraction of a second. And it doesn't really demand any close relationship between photographer and subject. To me, the way around this is an obsession. Certain areas do become obsessions with me. By going back to them and working again and again and again, I get past this superficiality.'

The first photograph stops the movement of the water in a fraction of a second, revealing rich textural detail. In such a close-up, the scale of the image is not obvious and the interrupted flow of this tiny stream becomes symbolic of much huger forces. The second picture was taken with a long exposure, so the move-ment of the water is not precisely recorded but blurred. Within that general blur, one can clearly see patterns of constant flow. This effect, rather like molten metal, is emphasised by the wider view. This makes the extent of the blur more pronounced and it contrasts markedly with the definite structures of the banks and rocks.

A rather sophisticated technique was used to produce the last picture. The image was built up through a series of short exposures rather than one long one. For example, if the calculated exposure was 1 second at f32, John Blakemore made 15 separate exposures at 1/15 second. Obviously one has to be very careful not to jar the camera during a situation like this and a rigid tripod is a necessity.

He tried this experiment first after seeing sunlight sparkling on the water, all the intense points of light. The multiple short exposures create an effect of almost electrical energy.

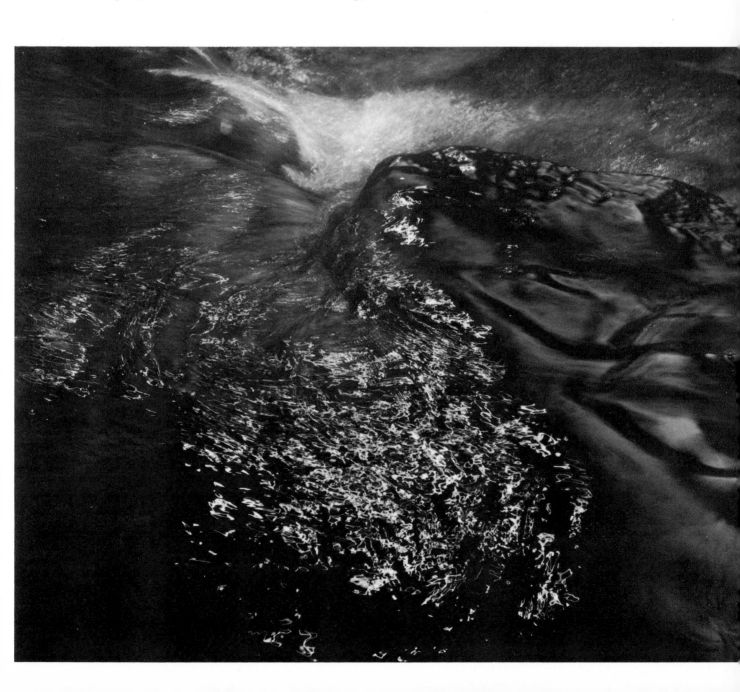

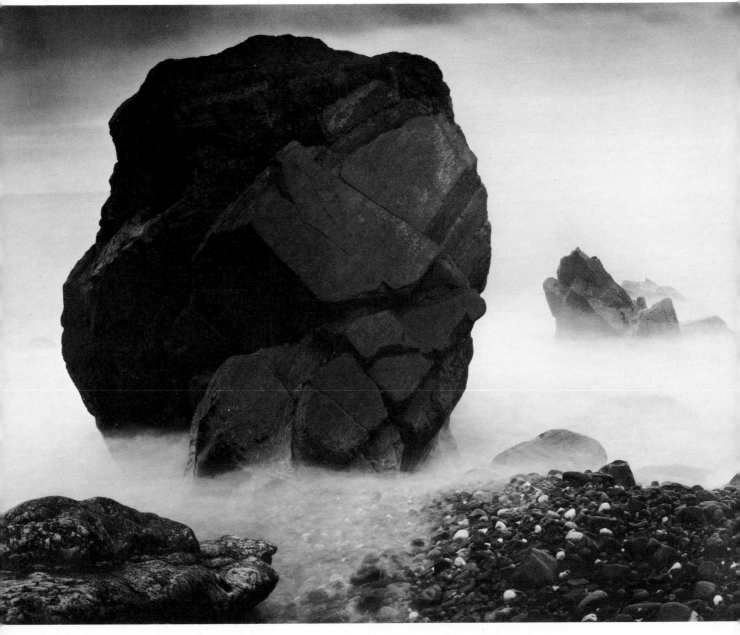

The theme of energy in landscape is closely related in John Blakemore's work to the expression of different concepts of time through photography. We have seen examples of this in the previous pictures, the constancies and change of water movement described through short, long and multiple exposures.

In this photograph of a section of coastline, the symbolism is quite explicit. A long exposure has recorded tidal movement around the base of the rock. As a result this base is partly obscured. This erosion in visual terms symbolises the process through time of actual physical erosion. John Blakemore does not produce these images as a totally detached observer. As he explains,

'What basically interests me in the landscape is the idea of cycle – the cycles of growth, decay, regeneration and so on, and how these processes can be seen as a metaphor of the processes which one goes through as an individual. So that they are external processes, processes of nature, but also processes of which one is oneself a part and which one can identify with.'

His relationship with his subject and with photography itself, is a close and personal one. Its significance to him is obvious from his words.

'One can walk past the same thing morning after morning and never see a picture there. And then suddenly because of a trick of light or a change in one's own mood, it all becomes different and one responds in a different way.

'I think that photography becomes a way of learning to see, a way of experiencing more deeply and of expressing things that perhaps one wouldn't have seen originally.'

Photographs by WYNN BULLOCK

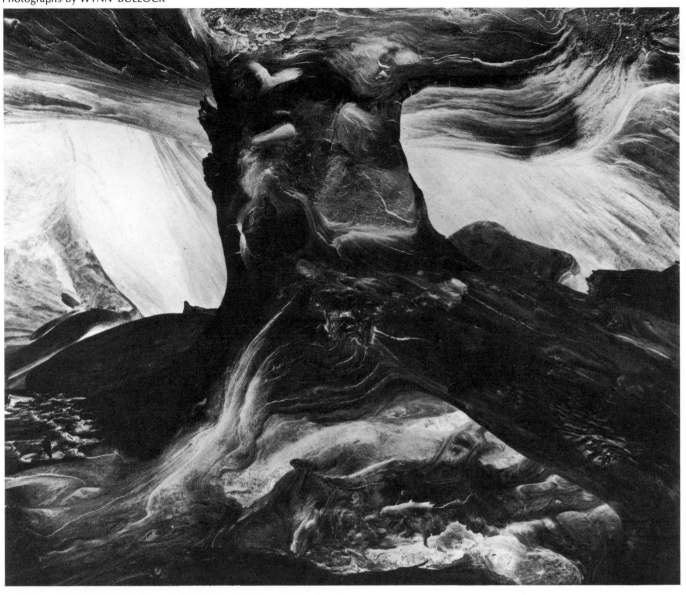

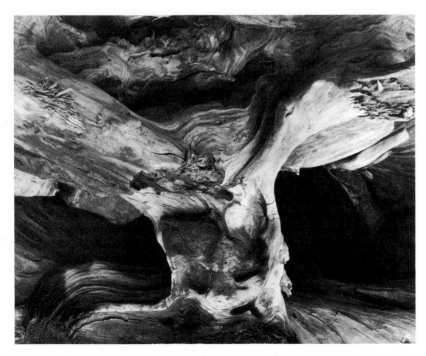

Compare these two photographs by Wynn Bullock. The smaller, of a section of an old tree trunk, is rich in detail, in the flow of line and in its subtly luminous quality.

The other image is much less recognisable but exceptionally powerful. Is it water, rock, an explosion, an aerial view of a delta, or perhaps even a composite picture? It doesn't much matter what the nominal subject is. One feels that it is essentially about natural forces, about energy, turbulence and change.

In fact the top picture is a negative inverted image of the bottom one. This was a favourite technique of the photographer. By making the image less recognisable, he strengthened its symbolical expression and challenged the reader's imagination.

3 Movement

Movement is often nothing more than an incidental problem to the photographer, something he controls quite instinctively. Sometimes it is more demanding and requires quick reactions or exact timing. It can be used as one variable in a complex composition or as an end in itself, the expression of movement for its own sake.

At the simplest level there are two opposite approaches to photographing action of any kind. A high-speed exposure will stop the subject at any point of movement. A longer exposure allows the subject to continue moving and so it is recorded as a blur.

An image of 'frozen' action can be full of fascinating detail but lifeless, because the sense of movement has been lost. A blurred picture conveys the sensation of action but can obscure important detail. The choice is between information and impression. But between these extremes several compromises are possible.

More complex interpretations can also be explored. We have already seen how John Blakemore builds up cumulative layers of movement detail in a single image through multiple exposures (pages 46–47).

The illusion of movement can be exaggerated or even created. The progress of an action can be analysed within one or a series of photographs. Finally, there is what one might call the personality of movement – grace, tension, effort and even humour. It is a rich area, both in black and white and colour.

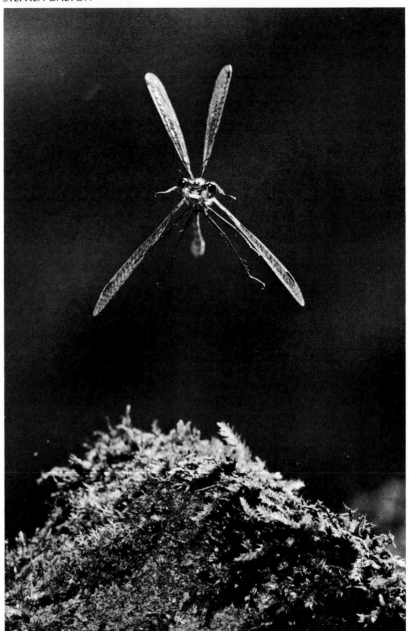

Technical perfection is not an absolute standard in photography but very much relative to what you are trying to convey. For instance, unsharpness can be more effective at times than a totally precise image.

In Susie Fitzhugh's photograph overleaf, the girl is suspended in mid-air and we are fascinated by the detail of an action too fast for the eye to record properly. But the movement continues. It has not been totally eliminated, it is still suggested by the blur of the feet and the tips of the hair. That is why the picture seems so spontaneous and vital.

Professional photographers are well aware of this effect and often deliberately avoid using the fastest available shutter speed even with the most rapid action subjects. They prefer to use a speed that gives a good compromise between 'freeze' and blur.

Stephen Dalton has developed a highly efficient technique for photographing insects in mid-flight. Their movement is incredibly fast and erratic but his high-speed flash unit, triggered automatically by the path of the insects themselves, 'freezes' their action and records every detail. The pictures are not merely informative but also beautiful.

The opposite extreme is shown in the picture by Chris Smith of a rowing eight shot from above. In factual terms it may not say much but what a stunning impression of movement it gives. The effect was created by using a slow shutter speed so that the boat moved appreciably during the exposure.

Professionally, it was a brave photograph to take. There was no chance to hedge his bets. He had to back his judgement.

One way of controlling the degree of blur and sharpness in photographing a moving object is to pan the camera. That is, one swivels with it, relative to the speed and direction of the subject. If you have watched someone following a race through binoculars, the principle will be obvious.

The subject is picked up in the viewfinder well before the exposure is to be made. Then the camera is moved smoothly round, keeping the subject centred in the finder. The camera is not swung across the face of the body but the body itself is used as a pivot. Just before the subject is opposite, the shutter release is squeezed and the movement is followed through.

That is the basic technique and of course it can be adapted according to circumstances and one's experience. But smoothness of travel is critical to the effect. Even very fast-moving subjects can be photographed with a slow shutter speed and still be recorded with surprising sharpness. For instance, Eamonn McCabe used 1/60th second in panning with the sprinters below. It is the combination of clarity and blur that is so appealing, giving a definite impression of movement and yet retaining enough informative detail. The shutter speed should be adjusted according to the speed of the subject and the result required.

Notice how blurred the background is. One advantage of panning is that it concentrates attention on the immediate subject by making other elements indistinct. This 'smearing' can be very effective in colour – see page 64.

The pictures opposite are two classic illustrations of the imaginative application of blur. In both cases the camera itself was still and also most of the subject. The movement effect was very localised. In Otto Steinert's photograph of a Paris street, the pedestrian has all but disappeared.

EAMONN McCABE

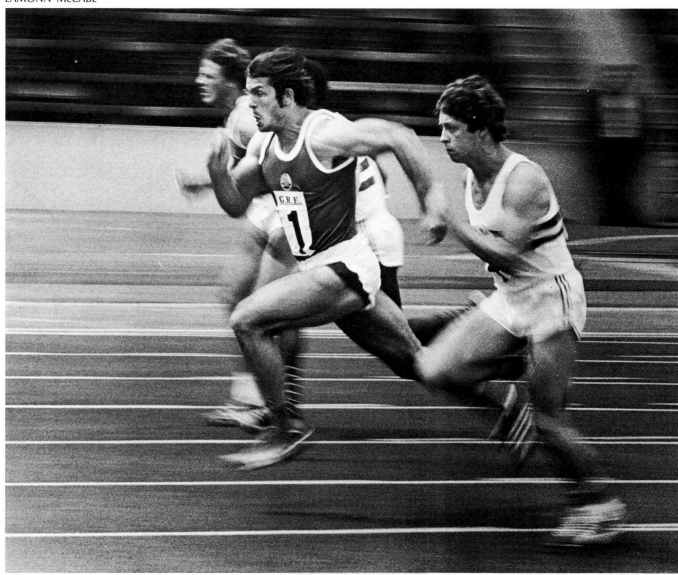

During a 1/4 second exposure, his movement has blurred him almost into nothingness, apart from that solidly placed foot. But is the explanation really that simple or was there an extra touch of contrivance? Was the person moving much faster or more erratically than one first assumes? Does the form of a body really disappear so quickly at such a shutter speed? The questions start to nag one into experimenting oneself.

Edward Steichen photographed Thérèse Duncan on the Acropolis in 1921. The wind flattened her clothes against her body and the ends of the material flapped and fluttered so much, Steichen recounts, that they actually crackled. The visual effect is equally startling, the blur of clothes looking just like flames. Steichen titled the picture, 'Wind Fire'.

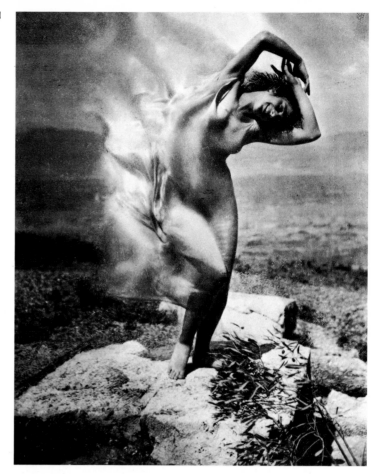

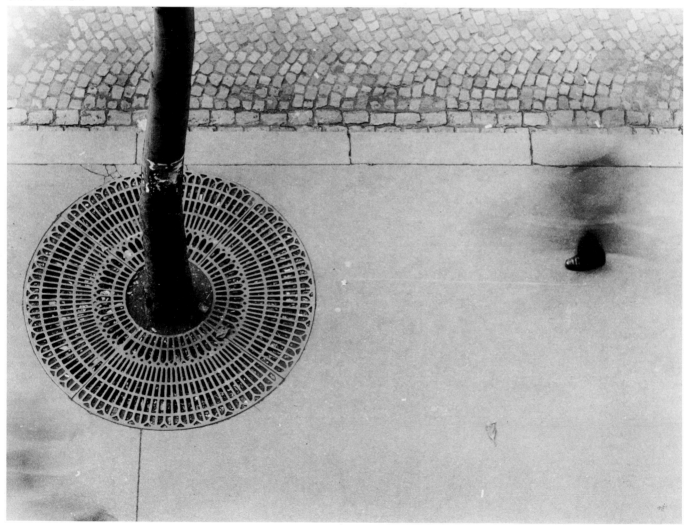

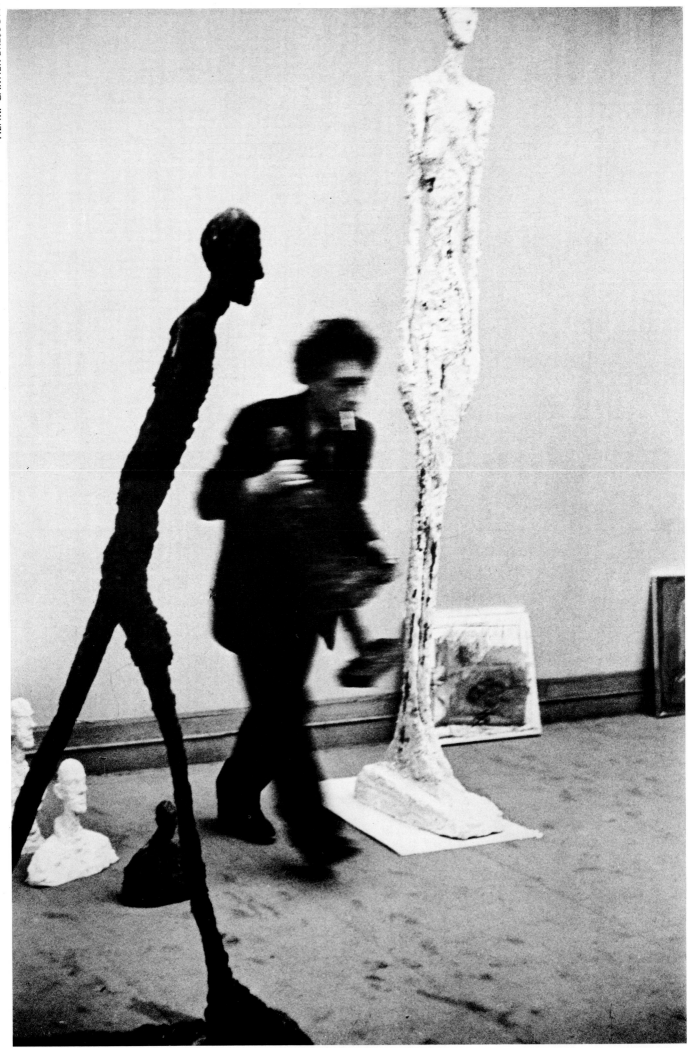

Both these photographs show the control of movement within a quite complex framework and they share a certain underlying philosophy.

This was best expressed by Henri Cartier-Bresson himself, who took the photograph of Giacometti, opposite. In essence what he says, is that for him, content is inseparable from form. The visual structure of an image is an integral part of what it communicates, it is not something superimposed on the basic subject material. He summed up, 'To me, photography is the simultaneous recognition, in a fraction of a second, of the significance of an event as well as of a precise organisation of forms which give that event its proper expression.'

Since there is a common tendency to quote the words of great photographers like Holy Writ, it is important to remember that Cartier-Bresson also emphasised very clearly that he was not defining photography for everyone, just for himself.

The moving subject is precisely placed in relation to his sculptures and the overall space. That relationship *is* the photograph. The figure on the left provides a witty counterpoint to the form of its creator and a direct contrast between the sculptural and the photographic image. The blur points-up that distinction and suggests nervous excitement and living energy.

The interrelationship of figures and background in Burk Uzzle's photograph is so complex. To achieve that balance within such a variety of movement was remarkable. The graphic effect creates a strange feeling of dehumanising environment and anonymity.

BURK UZZLE

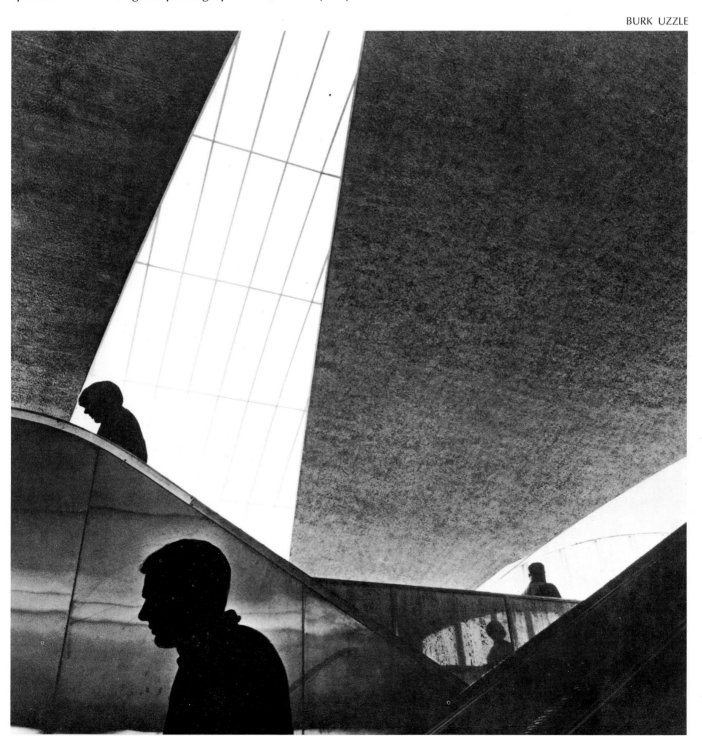

The progress of a movement can be recorded in a series of photographs or even in a single picture. One method is to use a strobe-light that flashes intermittently at high speed. The camera shutter is opened for a short time in dim light and every flash captures a separate stage in the action, on the same piece of film.

Zoltan Glass employed a multi-flash technique for his picture of Violetta Elvin, arranging six electronic flash units to fire at split-second intervals during a single jump. By placing them on both sides of the ballerina, he showed her in semi-silhouette.

Anthony Howarth and Alex Low used no less than twelve electronic flashguns to photograph Sally Stapleford at St. Moritz. These were wired up to four cameras fitted with different focal length lenses.

There were two major problems. First, they wanted to catch her at different positions on the ice. Second, for the sake of atmosphere, they wanted the background to be visible but without overwhelming the main subject. They decided to set a standard aperture and the flash/subject distance was carefully estimated in each case and adjusted for effect. Working at dawn or dusk gave them just enough light on the background. One of them opened the shutters and the other fired the flashes using a rotary switch. There are more details of the full assignment overleaf.

Gerry Cranham did not use flash for his picture of Chester Barnes but made multiple exposures by tungsten light. It was a demanding technique both for himself and the player but it allowed him to control the combined effect of blur and sharpness to his own satisfaction.

ZOLTAN GLASS

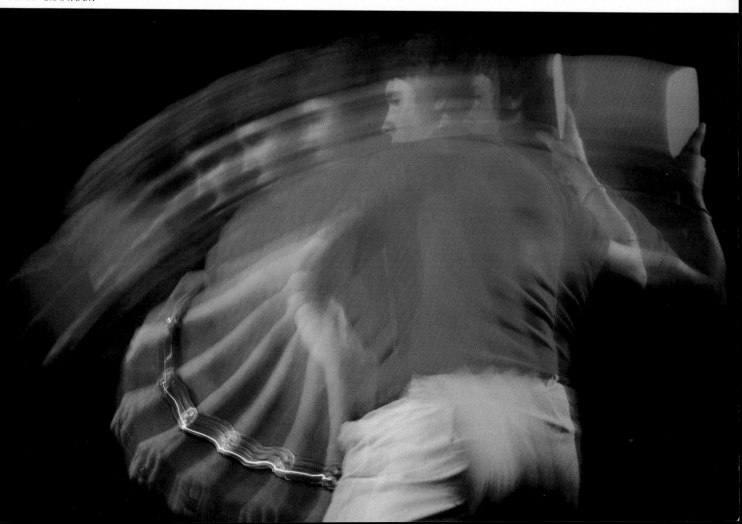

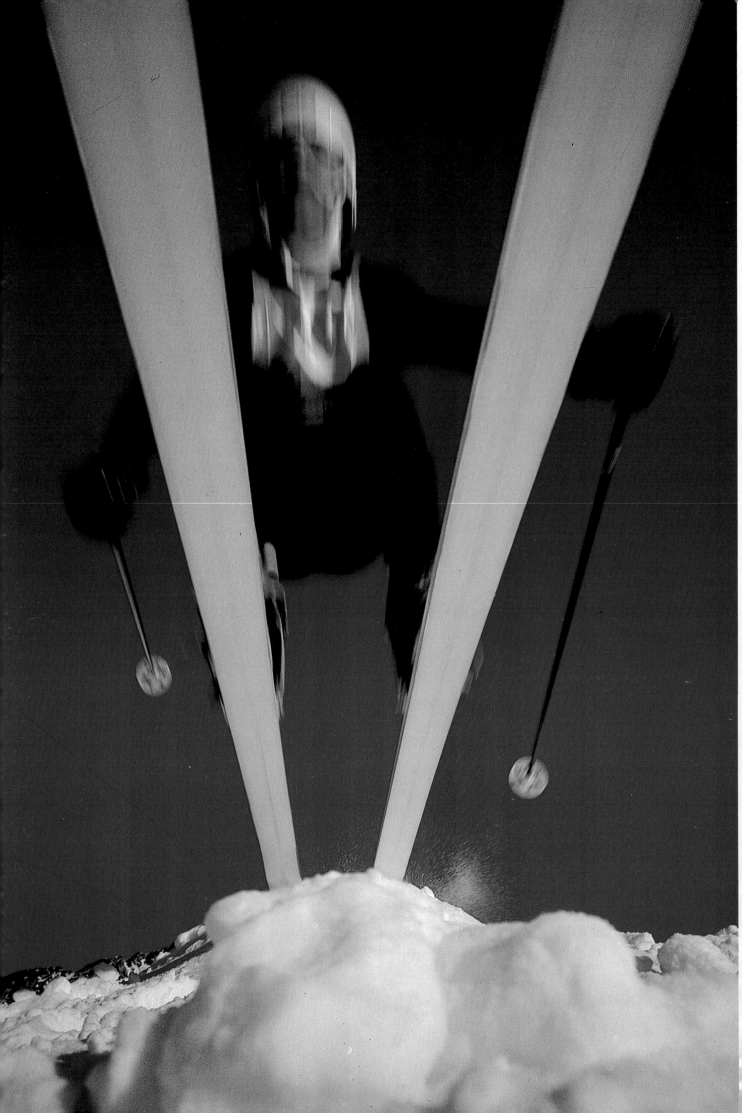

Photographs by ANTHONY HOWARTH & ALEX LOW

The ice-skating picture on the previous page and both these photographs, were taken by Anthony Howarth and Alex Low for the 'Weekend Telegraph' magazine as part of a highly adventurous feature on the 1968 Winter Olympics at Grenoble.

They worked closely with the British team during practice and set up their equipment right at the heart of the action. To take the picture, below, a motor-driven 35mm camera fitted with a fish-eye lens was fixed at the end of Gina Hathorn's ski. A remote-control cable led up to her hand and she pressed the button during her descent.

A similar technique was used for the photograph opposite, but because it involved greater uncertainty, four cameras were employed. Fitted with wide-angle lenses, 21mm and 28mm, they were placed below a small mound of snow, enough to make the skier take off. Another of the team triggered the releases as Howarth and Low shot other pictures. They repeated the operation several times, and just as well. Of the hundreds of frames exposed, only three included the skier.

It isn't really too surprising. The motor-drive was operating at four frames per second. The skier was travelling at about 60 mph, that is, about 88ft per second. If the button was pushed just a fraction too soon or too late, the skier would have moved some 22ft before the camera recycled.

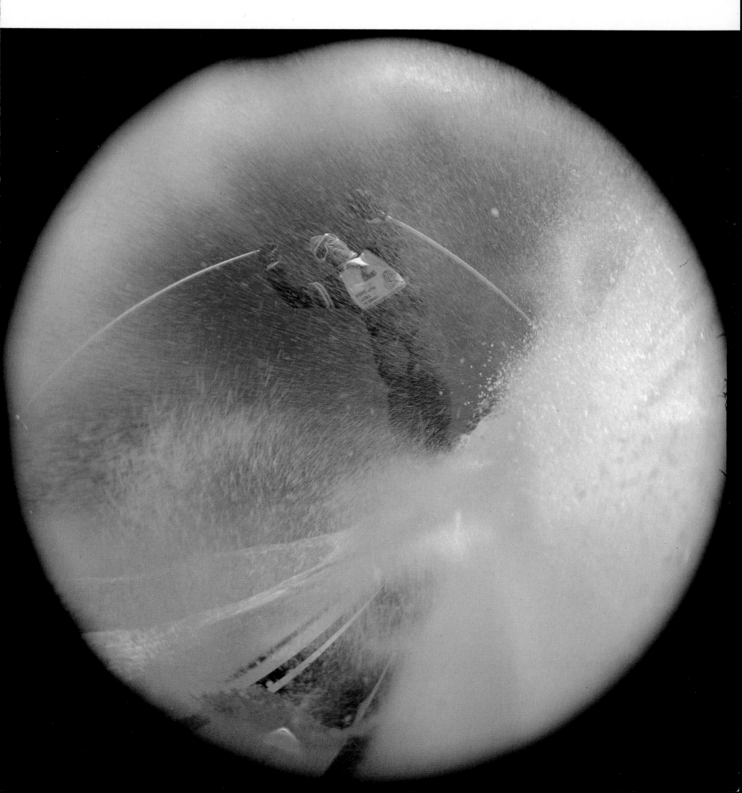

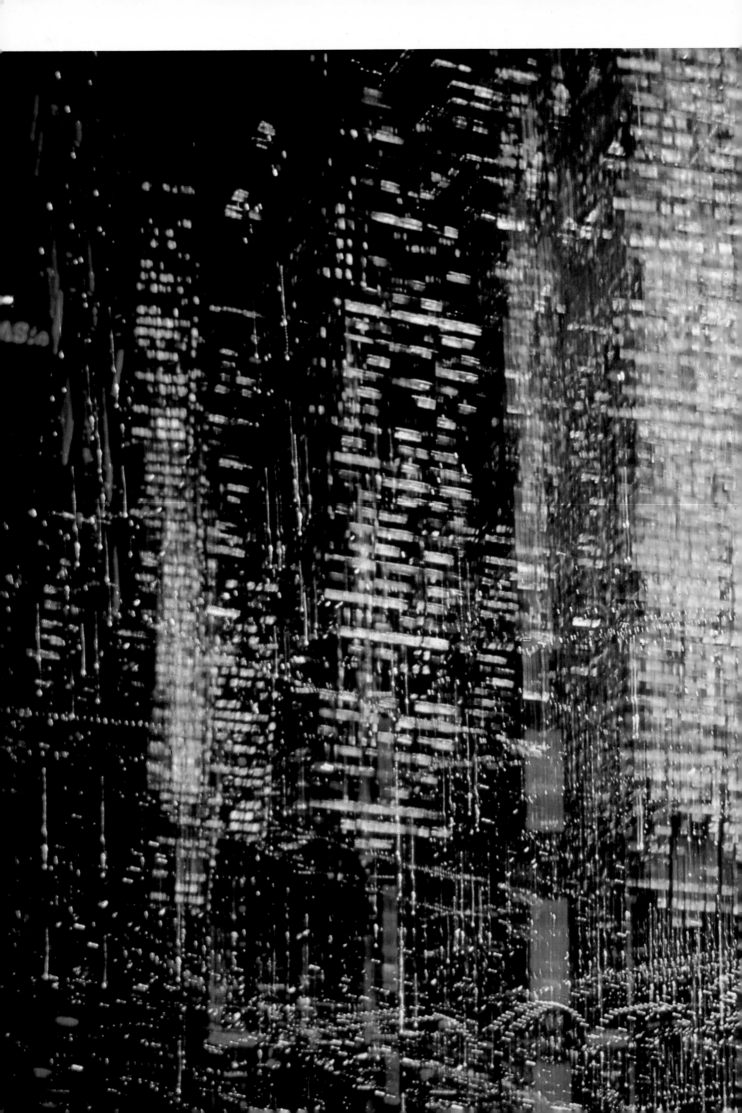

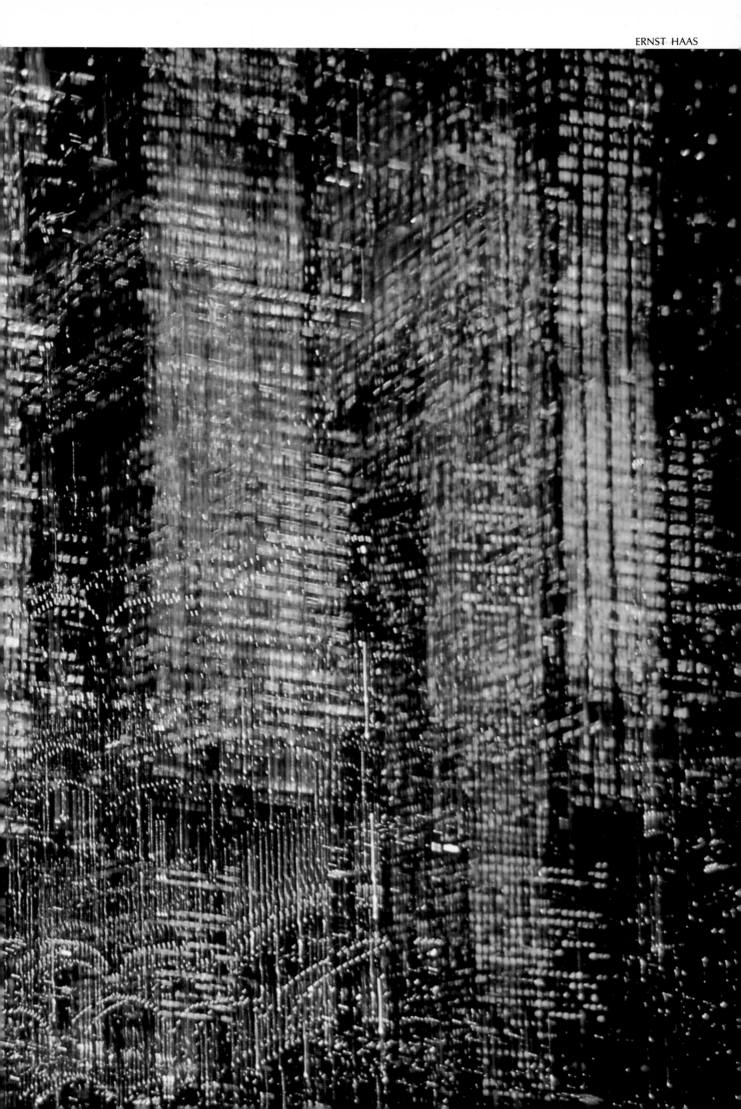

Whatever his other achievements, one first instinctively associates Ernst Haas with his colour-blur photographs of movement. The guiding principles were outlined at the start of this chapter – the use of a slow shutter speed so that the subject moves during exposure and is therefore recorded with some degree of unsharpness and distortion.

In colour this can be extremely attractive and it was Haas who refined this technique and gave it his own individual signature. It began by accident in the early 50's. He was photographing a bullfight, using Kodachrome colour film, then only 12 ASA, and very slow for the job in hand. Whenever the action switched to the shadows of the ring, he had to use such a slow shutter speed that the movement was inevitably blurred. Intrigued by the results, he explored them further and the eventual set of pictures was both successful and influential. He proceeded to adapt his methods to a range of other subjects, from water-skiing to American football.

The technique is not as casual as it may seem. Haas adjusts shutter speeds carefully, according to the effect he wants to create.

He keeps the subject recognisable, often retaining a relative sharpness in part of the image for the eye to hold on to. Sometimes a simple panning movement gives him enough control. Other times the action is more erratic, as with this rodeo picture. To bring out the colour as he wants, especially the fainter traces, he under-exposes by one to three stops.

The double-page picture overleaf, is not an exercise in describing movement but in suggesting it, in evoking a thrilling sense of urban vitality. Four separate exposures were made on the same frame of film, using different angles and moving the camera up and down.

ERNST HAAS

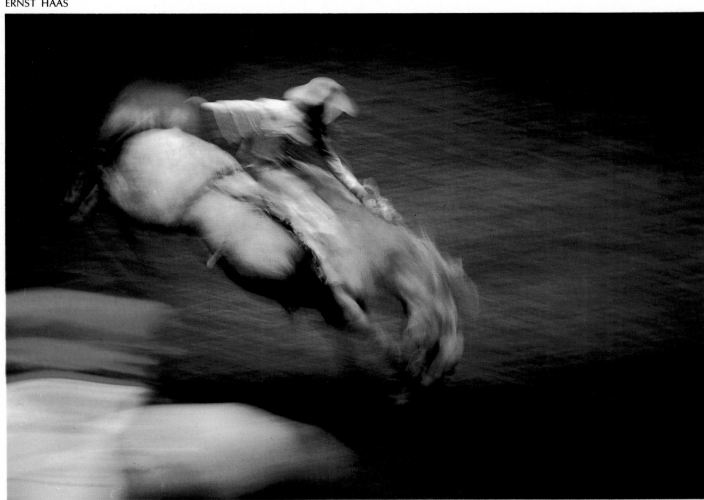

Interchangeable lenses are far from being gimmicks. They extend the practical range of the medium and also its expressionistic possibilities. But these effects can become tiresome if they are over-used.

This is especially true of the zoom lens which can produce a very flamboyant image, with blurred streaks radiating from a normal central area. It is caused by the focal length of the lens being changed during the actual exposure.

From watching television, you are probably familiar with the gentler use of this technique. At a sports event, for instance, the picture on the screen will gradually change from a general view of the playing area to a close-up of one competitor. If this were done suddenly, it would be quite startling. In fact, it is used sometimes for dramatic effect, both on television and the cinema.

In still photography, this transition from telephoto to wide-angle vision, is concen-trated into a single image. The skill is in timing the zoom properly and carrying it through smoothly. Various subtleties of effect are possible with experience.

This technique greatly enhances the sense of action and it can even create an impression of lively movement with a stationary subject.

Gerry Cranham has experimented with several zoom lenses and many methods of operation. He was particularly curious about the difference in results with subjects moving at various angles to the camera.

In this photograph, a very simple situation has been given an extra visual 'kick' by the use of the zoom. It made something out of nothing. One has to admire the photographer's co-ordination in panning with a fast car, making the exposure and zooming the lens simultaneously.

GERRY CRANHAM

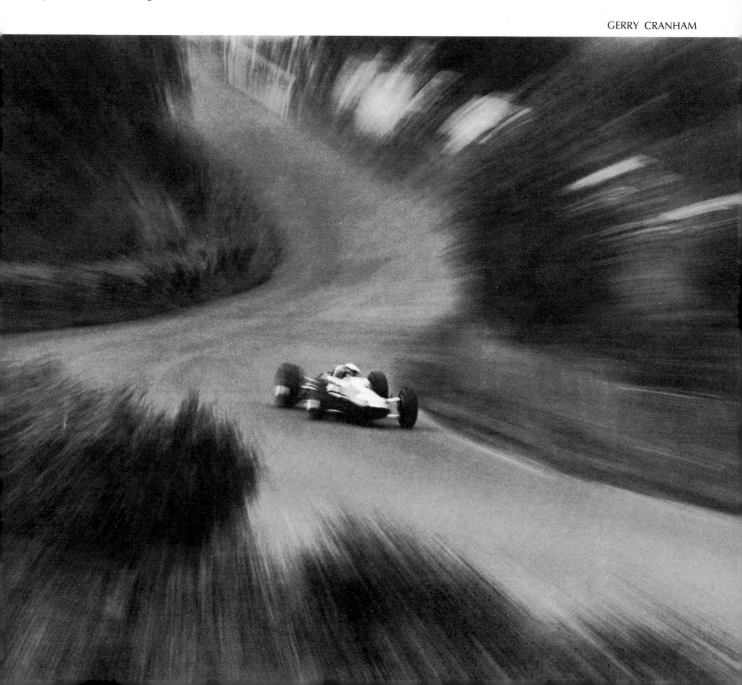

Sports photographers in general are noted for their efficiency and inventiveness in producing strikingly different pictures. They have a flair for taking advantage of the latest equipment and a determination in following through visual ideas.

Gerry Cranham is an excellent example of the breed. The range of his work is exceptional and his best pictures are characterised by a pronounced sense of visual adventure.

Both these photographs illustrate this clearly and the one below is particularly uninhibited. It is a montage of thin strips cut from two identical prints and very cleverly assembled.

Instinctively, the eye would like to move smoothly along the elongated image but this flow is repeatedly and rapidly interrupted by the specific detail. One is aware of the extended movement and yet constantly jarred by the minimal and conflicting information as one scans the picture. This latter effect is similar to that caused by stroboscopic lighting. You may have experienced this in dancehalls or discotheques.

More conventionally constructed but still highly imaginative is the photograph on the right, of trampolining. It was taken in a short interval during a championship event, with all the usual restrictions. It is typical not just of Cranham's eye for a picture but of his boldness in attempting the unconventional even under pressure.

The camera, fitted with a 'fish-eye' lens, was placed under the trampoline frame and fired by a long release. The gymnast was silhouetted against the fabric by light from the electronic flash units rigged along the balcony by Cranham.

The silhouette is quite a popular device in sports photography, giving strong immediate impact and conspicuous design.

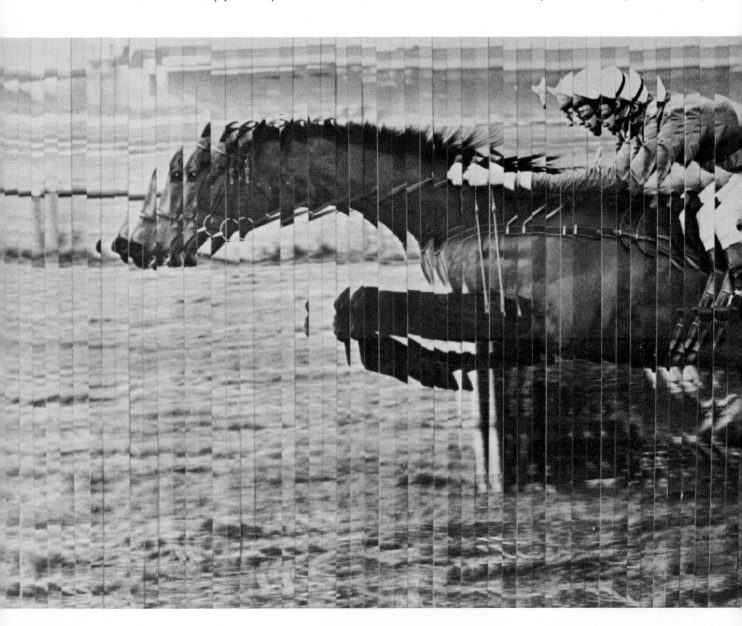

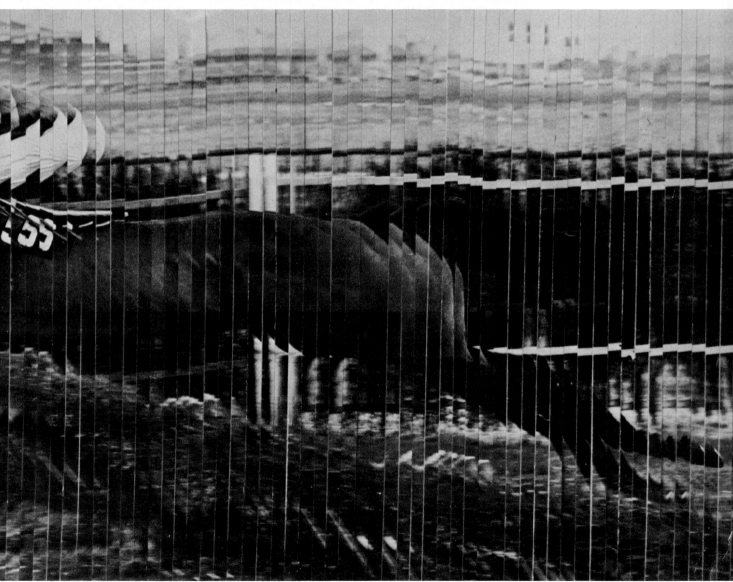

Photographs by GERRY CRANHAM

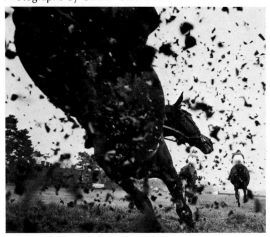 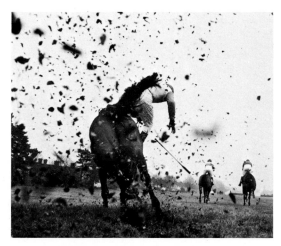

Fundamentally the picture series is a very simple approach to the description of movement, telling a story by consecutive narrative images. No special equipment is necessary until the action becomes very rapid and/or the analysis required is very detailed. Then the motor-drive unit becomes an invaluable tool.

These photographs took four years and a few seconds to produce. The seconds were the period of actual drama and exposure. Four years was the time Gerry Cranham spent planning and waiting for the set of pictures he knew was possible.

At first glance they may seem to be just the result of the photographer being in the right place at the right time. They are that but also much more. This series is a classic example of the photographer's patience and persistence in following through an idea to a conclusion.

Always alert for unusual viewpoints and the chance to take pictures right at the heart of the action, Gerry Cranham set up a camera fitted with motor-drive and remote-control leads underneath an actual jump at a race meeting. Camera and leads were of course carefully placed to avoid any danger to horses and jockeys.

As the horses cleared the jump, Cranham fired the release and the camera took a series of exposures, the film winding on automatically because of the motor-drive.

His first experiments taught him how best to angle the camera and gave him an idea of what effects were possible. A modest wide-angle, 35mm focal length on a 35mm camera, seemed the most suitable lens since it covered a reasonable field of view and produced an acceptable image size for objects in the middle distance. Incidents often happened outside the immediate landing zone and with too wide-angle a lens, this action would fill just a tiny section of the film.

After he perfected the basic technique it was a question of waiting till it paid off. And it was always possible for Cranham, or an assistant, to operate the remote-control release, while he also covered the action with another camera.

This sequence was taken at Sandown Park and shows Terry Biddlecombe falling from his horse, Notification, at the open ditch. It is a very dramatic step-by-step breakdown of the incident, from the first shot with its powerful use of viewpoint to the last image as the jockey hits the turf. The third picture, enlarged below, catches the peak of the action, Biddlecombe in mid-air irretrievably parted from his mount, and the air thick with mud and twigs.

Obviously under these conditions one is very dependent on luck but the best photographers learn how to improve the odds in their favour.

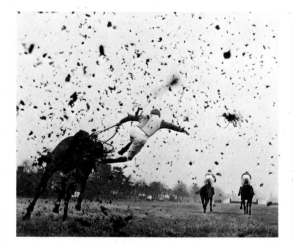
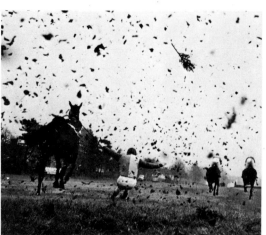

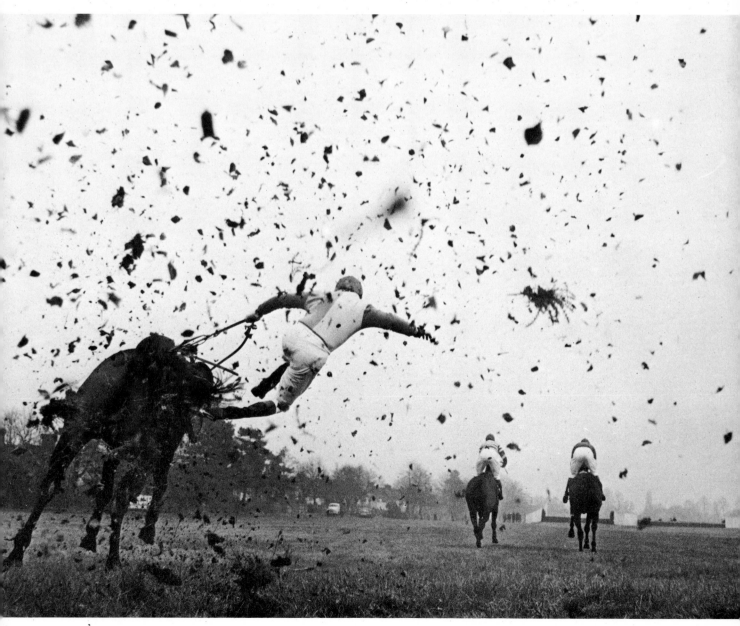

A single photograph is limited in what it can tell us about the development of the event it records. We have to interpret what happened just before and just after it was taken. But as we have already seen, there are ways of describing the progress of an action more accurately. Strobe flash or multi-flash equipment can record successive details of movement either as separate pictures or as one composite image. The motor-drive camera can expose a whole series of photographs in a single second. Or it can be adjusted to take one picture every hour, for instance, till the film runs out.

The simplest narrative method is the picture story. It has evolved into a very sophisticated technique but basically it couldn't be easier to produce and no special equipment is required. Straightforward narrative is just one possibility of linking photographs together and other ideas have been explored in depth over the last few years. The relationships of the images in these 'Sequences' have been wide-ranging but there is a noticeable tendency towards ambiguity.

Duane Michals helped pioneer this interest, introducing an element of obvious fantasy to quite mundane situations, which are then transformed. The stage management of these set-pieces is open and the climaxes are frequently bizarre but they can be surprisingly disquieting. Despite all we know to the contrary, they retain some degree of credibility.

The pictures below by Carol James describe a far more believable series of actions but they too have a strange, dream-like quality. The curious hopping movement, the facial expressions, the incongruous nonchalance, all add to the effect. The intervals of movement are very well spaced and the placing of the figure in relation to the background is satisfyingly precise.

DUANE MICHALS

CAROL JAMES

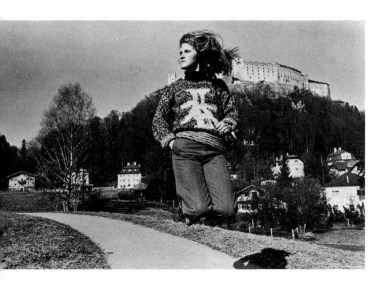

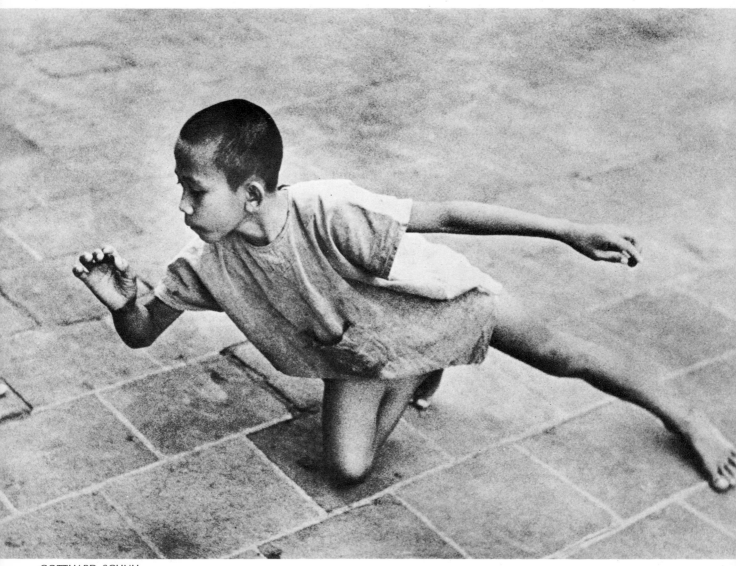

GOTTHARD SCHUH

Individual characteristics of movement, such as elegance or awkwardness, studied calm or impetuousness, offer an endless range of subject-matter. One doesn't depend on professional sport for opportunities. In fact, the crowds and the restrictions usually involved with major events, often lead to disappointment for the unprivileged photographer.

These qualities of movement are fundamental to everything we do, even though they can be more entertaining and more varied on special occasions. What could be more ordinary than a boy playing marbles in the street and yet Gotthard Schuh's photograph captures such a rare grace and poise. It could have been taken with the simplest camera.

The high camera angle outlines the shape against the plainest available background, as is the case with Hans Silvester's pictures, right. They are taken from his recently published book, 'pétanque et jeu provençal'. The competitors' personal styles of delivery are observed with affectionate amusement. The cumulative effect of a series of pictures of this kind often adds greatly to the pleasure.

One major advantage of an occasion like this is that photography is expected and potential subjects are concentrating strongly on the activities. With reasonable consideration even the most diffident camera user can work quite freely. A telephoto lens can be very useful for isolating details, especially if one has to operate from a fixed position.

Photographs by HANS SILVESTER

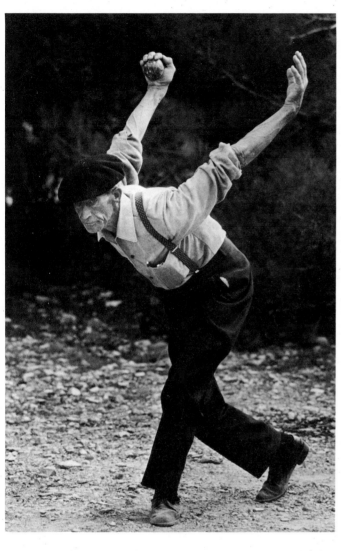
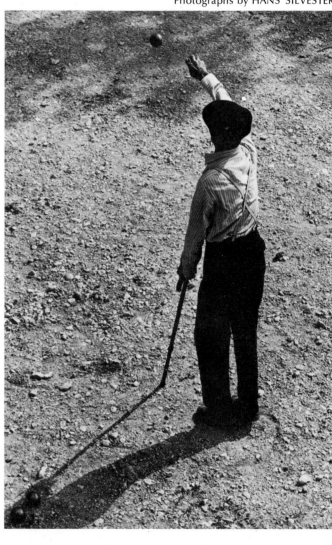
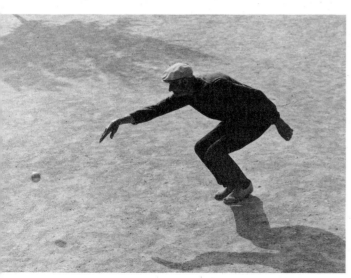
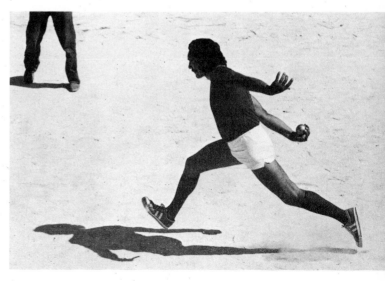

4 Social documentary

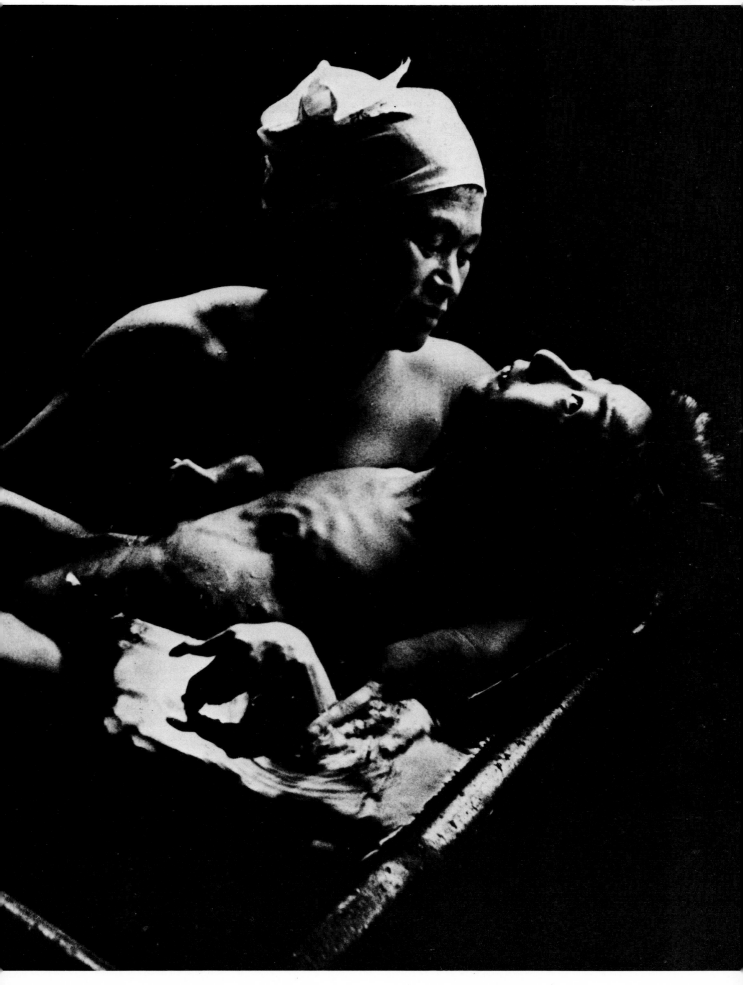

Social documentary is a convenient, if rather clinical label for photographs that record the way we live. This type of work is often described as photo-journalism and sometimes this is clearly accurate. But over the years, this tag has become ever more vaguely defined and today it probably confuses as much as it clarifies.

There is an undoubted love-hate relationship between journalism and photography. The profit and loss account is a difficult one to balance but today very many photographers in this area carry out their major projects independently of the magazine market. They want to work in greater depth than is normally possible on assignment and to control the selection and use of their pictures.

W. Eugene Smith is one of the legendary figures of modern photography who has always preached the rights and responsibilities of the photographer regarding his published work. The opening photograph is from his book 'Minamata', the story of the devastation of a Japanese town by industrial pollution.

Ian Berry was born in England but made his reputation abroad. He returned to London during the early Sixties and after re-establishing himself, began to plan a major photo-essay on the English. He saw it as a worthwhile project in itself and as a very personal rediscovery of his own country. He made a tentative start, then in 1974 he was awarded the first Arts Council major bursary in photography. This gave him the final stimulus and support that he needed. The first two images are an intriguing contrast in visual approach. The photograph below is essentially a composition in light and shadow. There is little detail but a dramatic isolation of back-lit faces against an almost silhouetted background.

In the picture opposite, it is the detail that fascinates and the absolutely precise placing of the figure. For instance, note the positioning of the head in relation to the width and shape of the street. That quality of instant judgement is what Cartier-Bresson meant when he wrote, 'In photography, visual organisation can stem only from a developed instinct.'

Photographs by IAN BERRY

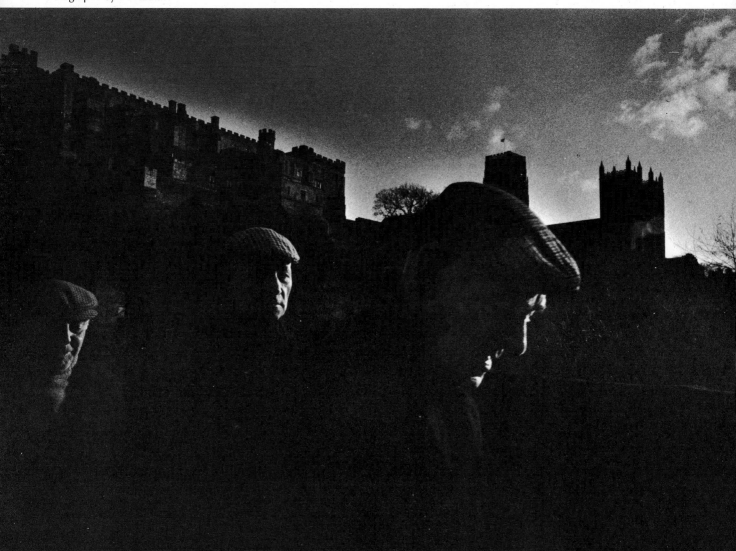

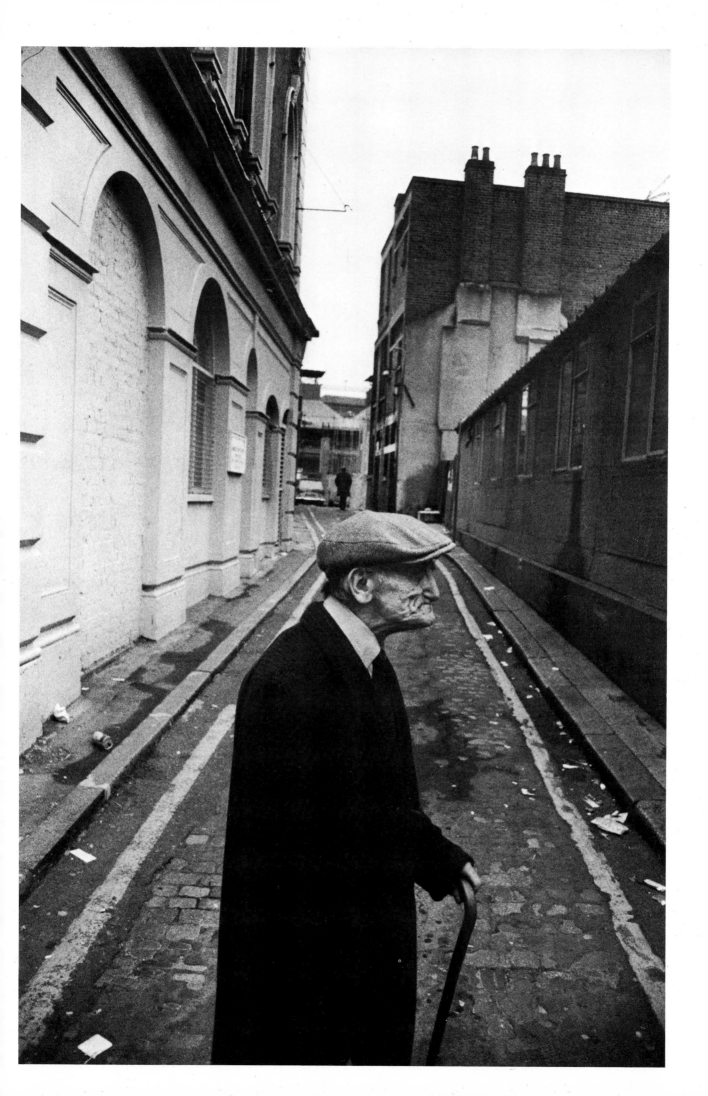

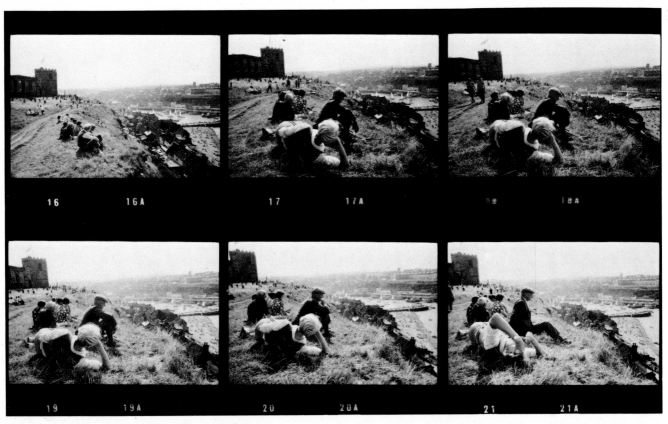

16 16A 17 17A 18 18A

19 19A 20 20A 21 21A

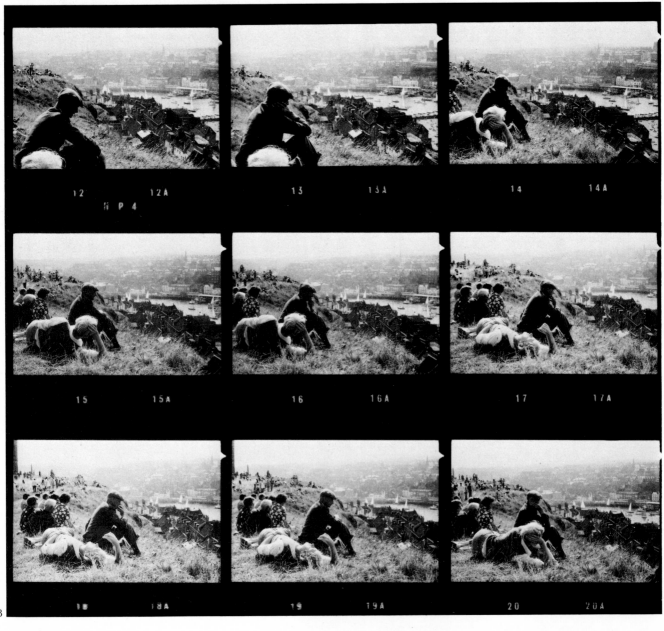

12 12A 13 13A 14 14A

ilP 4

15 15A 16 16A 17 17A

18 18A 19 19A 20 20A

A photographer's contact sheets are very revealing of the way he works. One can see frame by frame what excited him in a situation and what changes of viewpoint or lens he made in order to improve the original image.

Photographers vary enormously in the amount of film they shoot and also the reasons why. Sometimes it is simple indecision, sometimes just over-excitement. At its best, it is a purposeful investigation of the visual potential of a situation. Even then a certain wastage is inevitable as a photographer tries to balance complex interrelationships within fractions of a second. The two sets of contact prints on the left show how Ian Berry moved towards producing the photograph below. He was working with two 35mm cameras, one fitted with a 50mm standard lens and the other with a 28mm wide-angle. One can see what attracted him in the scene, his reaction to subject movement and the subtle but deliberate changes of composition.

Photographs by IAN BERRY

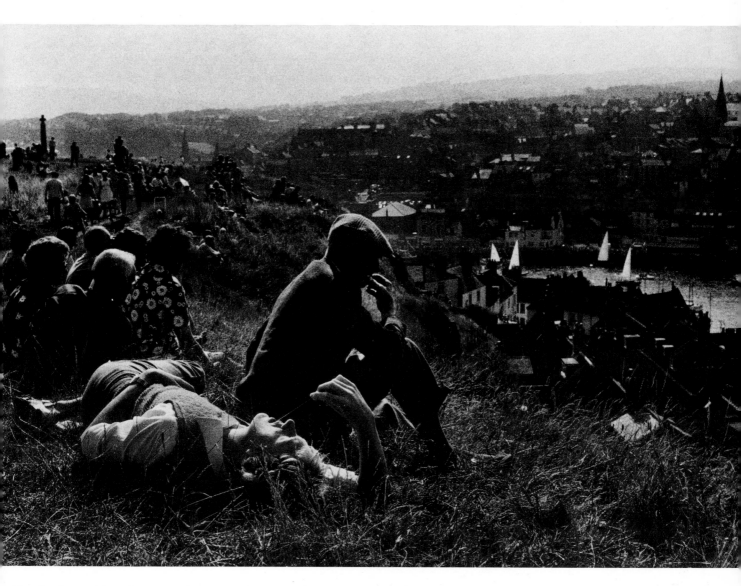

The basic problem here was how to relate the view to the people enjoying it. Visual decisions are a varying mixture of conscious and instinctive response but from these sequences it is obvious how deliberately Ian Berry explored the image possibilities.

Notice how he works with the strong diagonal shape of the hillside and how precisely he places details, such as the curve of the cap continuing the line of the slope. The final picture is about as accidental as a Bach chord.

The 28mm lens is first used to describe the overall scene. Then he moves in for a more striking foreground and favours the bay at the expense of the church at the top left. He catches the movement of the capped man and strengthens the diagonal even more. When the nearest man shifts, the composition is weakened and the photographer stops.

The 50mm lens gives a closer relationship between foreground and background. The untidy shape at the bottom left is lost by moving back and a shift to the left takes in more of the horizontal body. New arm positions are captured and there is a major adjustment as the nearest man rolls over on his back, the picture of relaxation. A fractional movement of the camera to the left and *the* picture is made. One man moves, notices the photographer and the sequence ends.

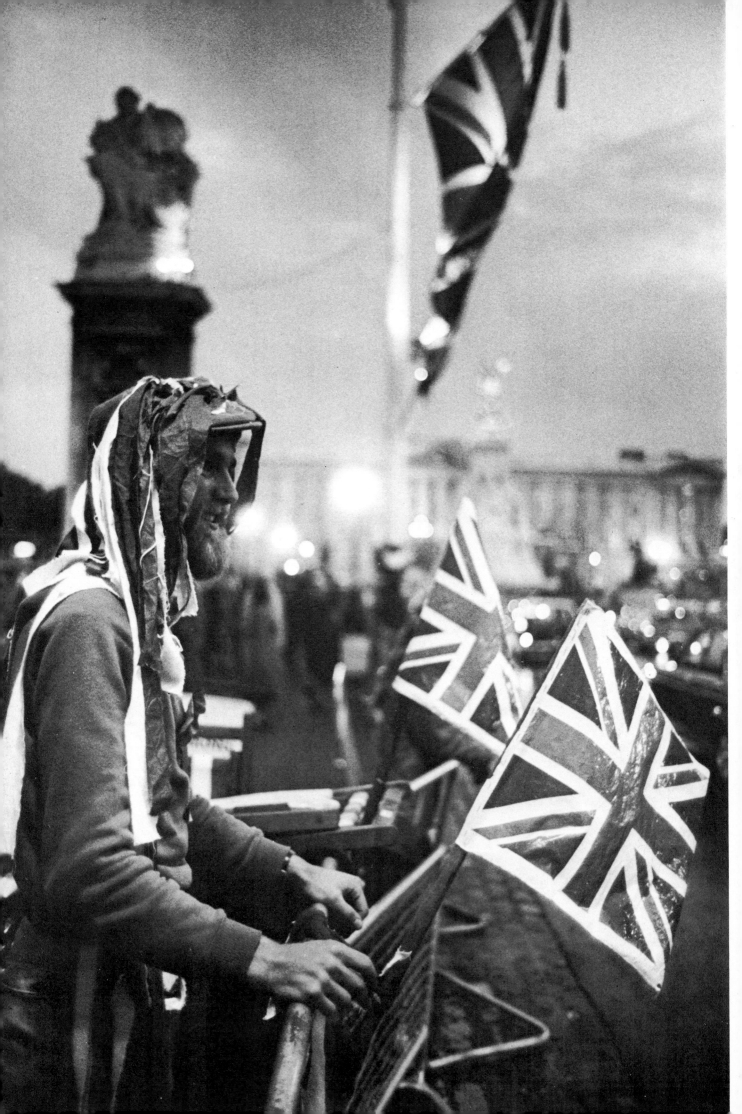

Marc Riboud took these photographs during the celebrations of the Queen's Silver Jubilee Year. It was a classic opportunity for the photo-journalist, with so much happening at so many levels, from formal State occasions to street parties. There was spectacle, colour, vitality and a remarkable degree of local community effort. It had the urgency of a news story but with plenty of chance to fill in the background detail.

When people respond to a public festival like this, the photographer should be in his element. He can try to produce a comprehensive record of the event or concentrate on any particular aspect of it. And he can expect to work with more than usual freedom, since people are enjoying themselves and both expect and want the celebrations to be recorded.

The major ceremonies, of course, are more strictly controlled but most professional photographers organise special positions, usually elevated, well in advance of the day. Some will still prefer to roam around in the streets, more interested in human reaction than in pomp and pageantry.

On this occasion, Marc Riboud managed a view of both. By the climax of Jubilee Day he was established on the steps of St. Paul's Cathedral, photographing the personalities as they arrived. But that dawn, in the pouring rain, he had been outside Buckingham Palace recording the situation there. And the previous day, there were the street parties to cover, probably the most lively and colourful of all the festivities.

One of the principal problems in every case was to separate interesting elements from the general confusion and yet to relate them clearly to the centre of events.

In the black and white picture, the dimly seen background is Buckingham Palace itself. In the other photograph, the patriotic colours speak for themselves. This image seems so simple but notice how carefully it is composed into foreground, centre and background areas.

At this time many of the world's finest photographers were working in London but it was a subject that could have been tackled by enthusiasts anywhere in the country, documenting the activities of their own community. On a smaller scale this opportunity always exists and is very worthwhile.

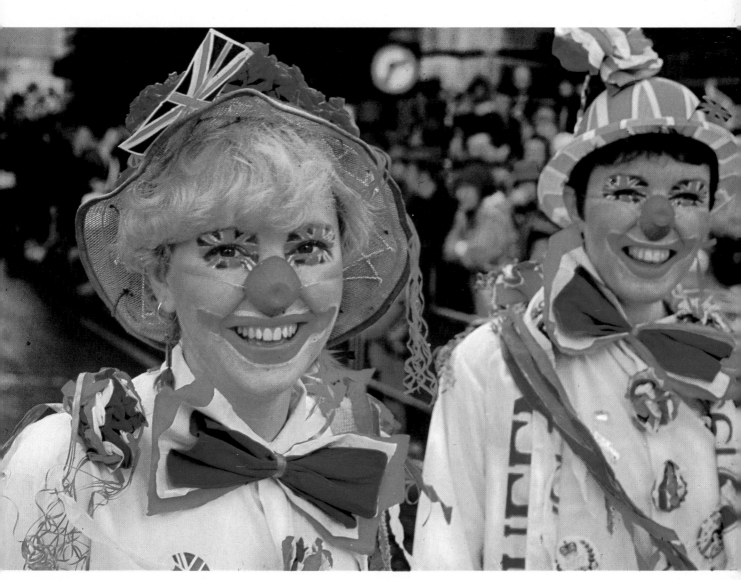

Photographs by MARC RIBOUD

Like the Jubilee revelry, carnival time is tailor-made for photography. Even more so, since the participants are actively vying for attention.

Adam Woolfitt photographed this magnificent costume in Trinidad, at one of the world's greatest annual festivals. A subject like this cries out for colour, even if most of the pictures end up looking too decorative.

In some ways this is an uneasy area of operation for the serious professional photographer. It is all too easy to work at a very superficial level, relying on the novelty and colour of the subject to produce entertaining pictures. Often of course that is exactly why one was sent there.

In the usual chaos of such events, a photographer can use a normal lens almost like a telephoto, to isolate particular detail. A wide-angle is often essential in the general scrum. This can be a good chance to experiment with such techniques as motion blur, discussed earlier, or open flash, discussed later (page 134).

An automatic camera can make it much easier to work in colour, with the constant movement of subject from bright sunshine to differing degrees of shadow and then back again.

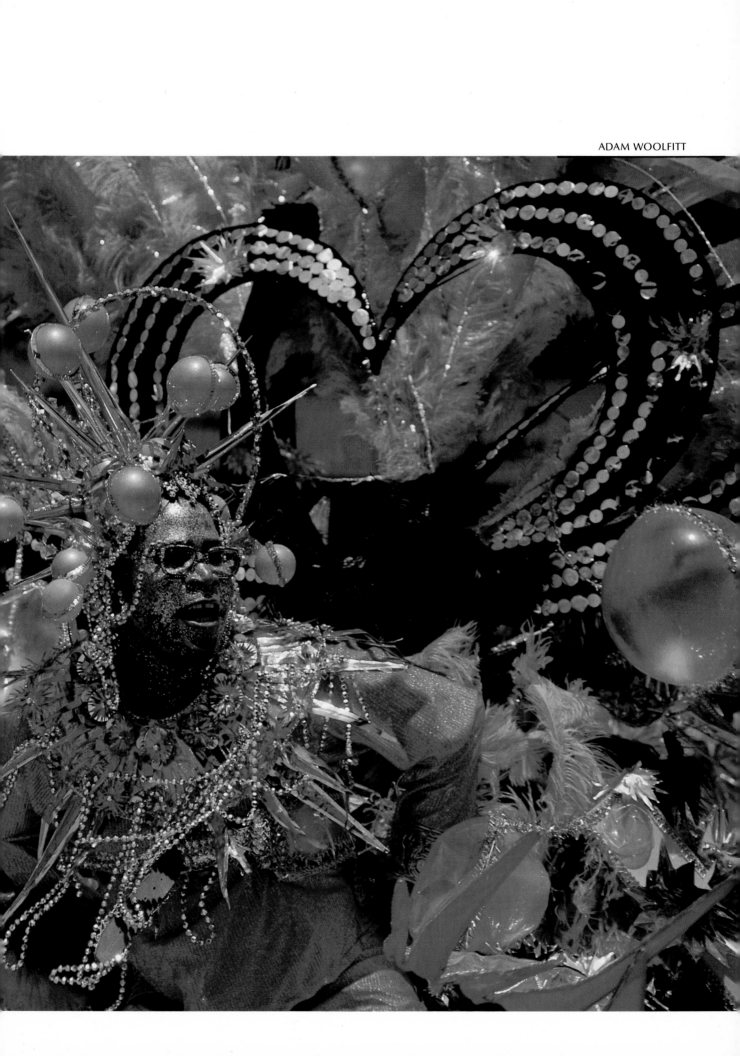

Bruno Barbey is a member of Magnum Photos, a small, exclusive, international agency that one joins only by invitation and that is co-operatively owned by the photographers themselves. As a commercial operation its policy has to be largely pragmatic but it still enjoys a reputation for an underlying idealism about photography and its social purpose.

Like many of his famous predecessors, Barbey travels the world documenting how people live, but unlike them, he works almost exclusively in colour. That is the demand of the market today and most of his colleagues have also had to adjust to varying extents. Sometimes they did so very reluctantly, since they were convinced that black and white photography was fundamentally a medium of more serious intent than colour. Originally for Barbey too, his commitment to colour was basically a professional one but he has grown more at ease with it in terms of personal expression and satisfaction and now he is confident of its role.

When the international magazine market became depressed and some of the biggest publications died, photographers had to make major changes in their operations. There was still a great demand for their pictures but from a huge variety of smaller magazines, books and other clients. Photographers realised the value of keeping a wide selection of work on file and they worked increasingly on a speculative basis, building up their library of pictures. To some extent it gave them a new freedom, since they were not subject to the usual editorial limitations. They could shoot what they wanted, as long as they produced enough that sold. Barbey took advantage of this opportunity, to work for longer and at more depth than might otherwise have been possible.

He avoids gimmicks in his photography but knows the value of a range of interchangeable lenses with his 35mm cameras. The pictures on the right, for instance, show two important uses of a telephoto lens, first to magnify distant, inaccessible subjects, secondly to dramatise a situation by compressing the detail.

He is also well aware of how to ring the changes with colour, sometimes aggressive, sometimes restrained. Similarly, some images are simple, others complex. Variety is an essential part of his work.

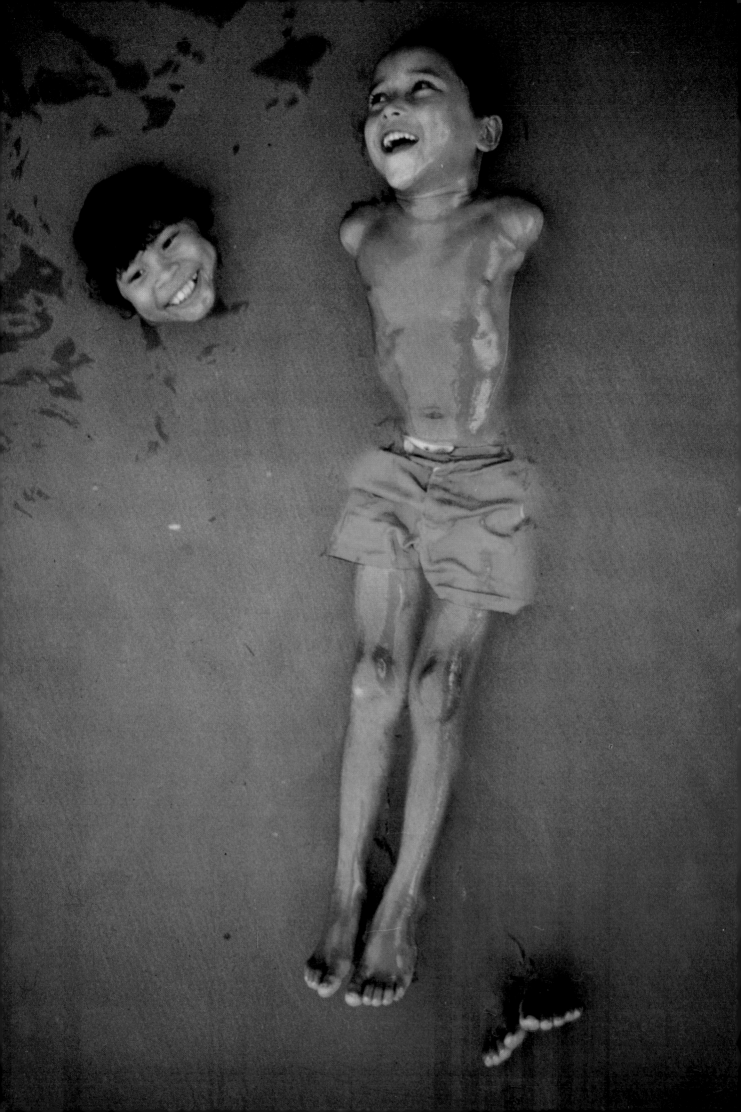

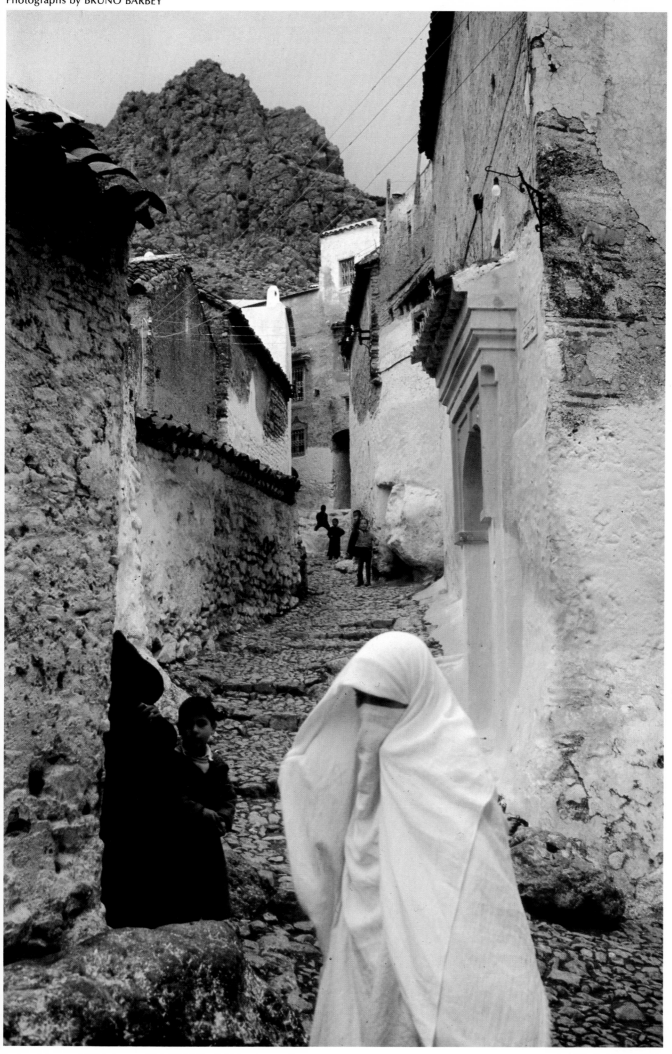

Flash used to be a dirty word to many photo-journalists but so did colour. In both cases the attitude was understandable and more practical than prejudiced. Flash made it impossible to work unobtrusively and often ruined the atmosphere of a situation, as well as the natural quality of the existing light. Colour was irrelevant and even detrimental to their purpose.

But once colour was accepted, it was almost masochistic to try to work in poor light. Slow film meant a vastly increased risk of camera shake and unsharp pictures. Faster films caused a marked loss of quality. Colour was lost in the shadows anyway. Flash was an efficient and convenient solution. It still had its disadvantages but photographers were able to take pictures that would otherwise have been impossible to catch.

This photograph of indoor action by Bruno Barbey is an excellent example. Only flash could have captured it. A curious result of the wide-angle lens being used, is that the size of the jumping girl is quite out of proportion to the window, creating a rather bizarre effect.

Newspaper photography is sadly under-rated in general, both in its achievement and potential. The best Press people are marvellously versatile and talented, with little resemblance to their unfortunate public image. Their work, covering a broad cross-section of social activity, offers in its entirety an unrivalled visual chronicle of contemporary life.

The tragedy is that so much similar material in the past has been destroyed or damaged. Hopefully, photographers now are more aware of the value of their pictures and try to preserve them.

David Newell Smith took the photograph on the right for 'The Observer', one Hogmanay in Glasgow. It has a quality far beyond that usually credited to the range of a Press photographer and yet it is not untypical of his own consistent standard, nor of that of several of his Fleet Street colleagues. The opening portrait of Chapter 1 is also by him, giving some indication of his various skills. Today his freelance work is mostly for magazines.

BRUNO BARBEY

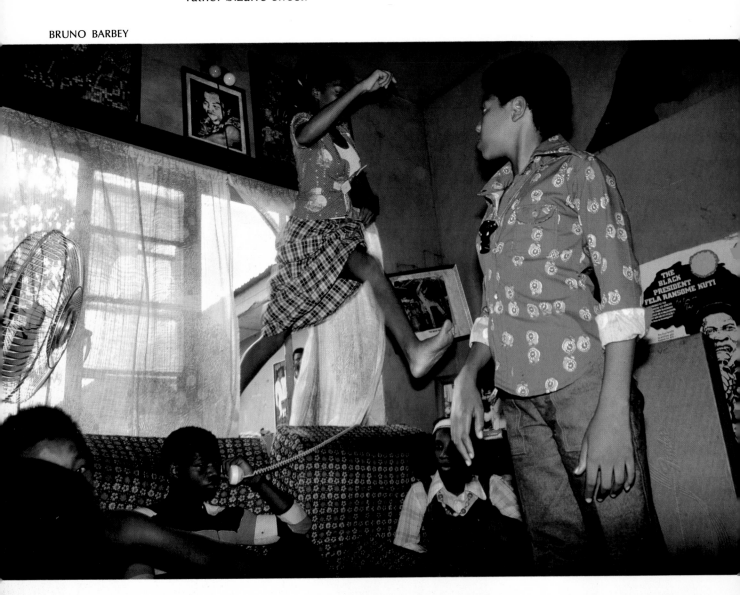

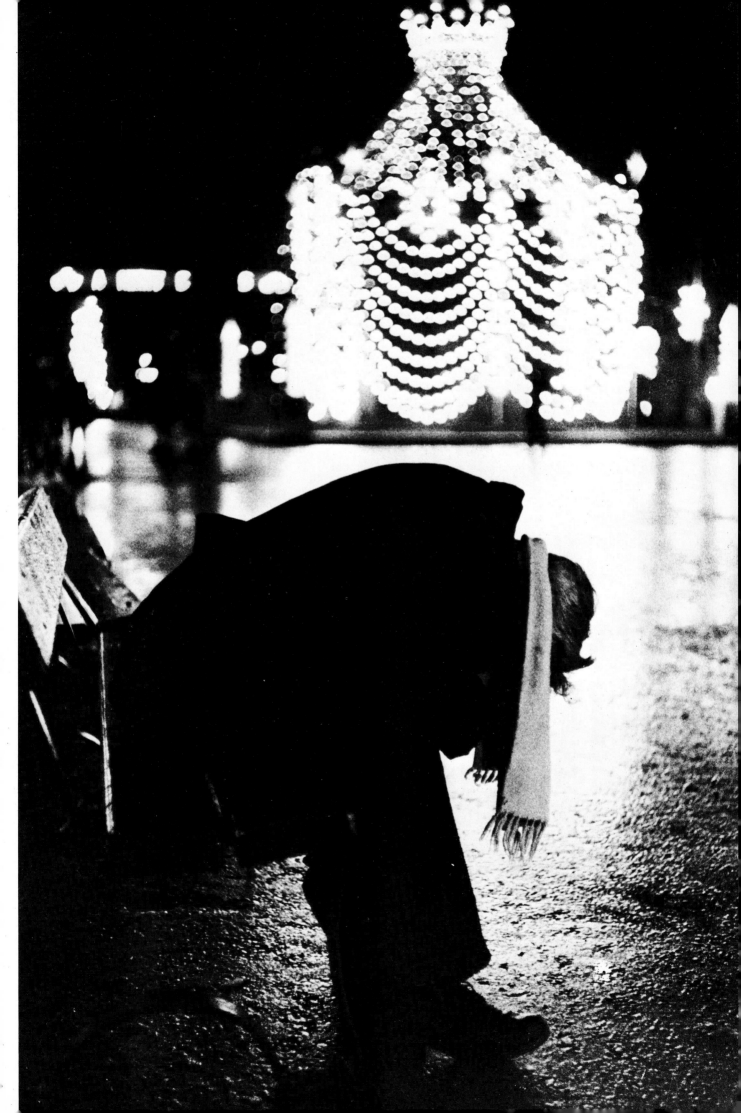

During his interview for the television series, 'Exploring Photography', Don McCullin was asked whether his new book was about the English or about the British. His reply was classic, 'No. It's about me.'

Even in general terms that is truer than many photographers realise. But McCullin was speaking of his quite conscious intentions. 'I've been living in other people's countries for years, watching other people die and suffer unnecessarily. It's had a profound effect on me. I'm trying to find out who the hell I am and where do I come from. I'm like a returned exile.'

There must be a strong motivation for a photographer at the height of his career to interrupt his professional business for many months to tackle such a job.

As with Ian Berry, there is no pretence that the book is giving a comprehensive picture of contemporary life in the U.K. It is an openly personal statement, inevitably limited by the time available to produce it but very intense and dramatic.

Photographs by
DON McCULLIN

Comparing the work of the two photographers is absolutely fascinating. It is an object lesson in discovering the extreme differences of approach and visual priority that co-exist under the loose heading of photo-journalism.

As these two pictures show, Don McCullin does not avoid direct confrontation with his subjects. He uses it frequently and the eye-to-eye involvement it creates, makes for strong explicit images.

It is almost as though it is a point of pride with him to meet any subject, like any challenge, head-on. It gives the reader a feeling of being right in the centre of the action, even though the formal qualities of the photograph have led the actual movement to be suspended. But though he declares his presence, he does avoid undue interference with a situation.

He enjoys eccentrics, as is obvious from the picture below, and even on a less bizarre level, the rather sombre tone of the book is not unrelieved by humour.

McCullin feels strongly that he wants his pictures to have a positive purpose. Talking about the photograph on the right, he explains how he came to take it. 'I was walking along and this woman said, "Who are you?" I said I was just a photographer.

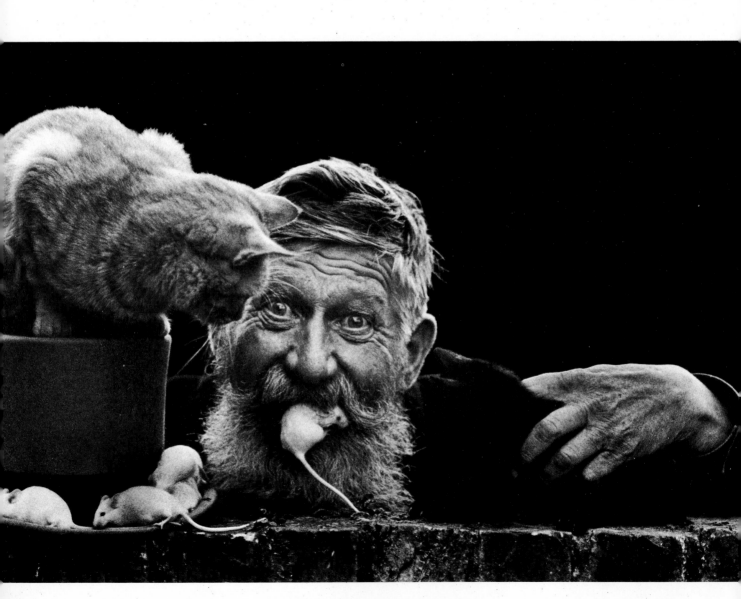

"Oh a photographer. Right, well you can come inside and I'll show you something, if you're from the papers". And she took me up into that room and I was flabbergasted. I asked if I could take some photographs and she said, "Of course you can. I want you to take photographs".

'These are the occasions when I feel really pleased about being a photographer. I'm really going to try and excel myself and do a fantastic job. Photography is one thing; using photography is another. I like being a photographer but I want what I do to be used, so that other people can benefit.

'There are many homes in England like that. If I could just get into them and photograph them and show people. I don't want my photographs to remain all their lives in yellow boxes and they're not meant for exhibition rooms. They're meant as a point of communication, to get them printed, to get them shown. Homes like that in England should not be allowed to exist.'

The impact of a McCullin picture owes much to its printing. And he works hard at it. 'I like my prints to jump out at the viewer and I inject a great deal of myself into my printing. I go into the darkroom and I talk inside me with my emotions, and I will that print to come the way I want it to. It's energy. It's all there in me. That's my hallmark, my print.'

The personal factor is the most significant one in all areas of creative photography, as in every medium of expression. Incredibly, there are still influential people in the Arts who think of photography as a mechanically controlled medium.

Don McCullin has no such doubts. 'Photography is an amazing business. It's a piece of sensitive emulsion put inside a piece of technology. But in effect that's got nothing to do with it, that's just a kind of scientific arrangement. The true arrangement is in my head. That's where my camera is, where my mind is. The energy of my photography is nothing to do with the piece of glass I look through. It's my mind and my thinking, that's my photography.'

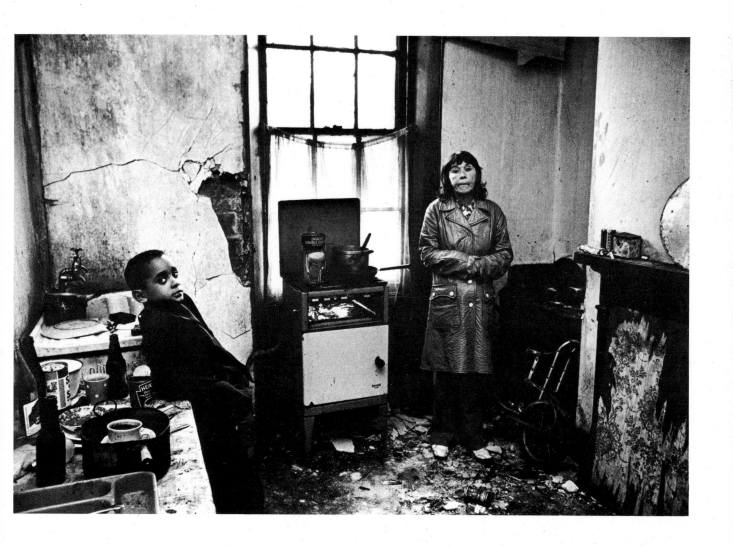

Taking serious stock of his work, David Hurn was well aware what a huge proportion of it had been taken on assignment and what a wide range of subjects it covered.

He realised how much he wanted to tackle a more personal project in depth and decided to take a year off to do so. The subject he chose was Wales. He has his roots there and it seemed a worthwhile exercise.

He became more involved than he could ever have expected. After five years work he is still shooting pictures. In the meantime, he has reorganised his career around this commitment.

He planned the operation as three stages. First, a very general coverage, almost a super-tourist approach. Second, a more selective choice of stories. Finally, getting to grips with the real nucleus of the subject, the elements without which the project would be incomplete, for instance, steel production.

He deliberately left this stage to the end, reasoning that otherwise there was too great a risk of anti-climax. One could logically expect the most powerful photographs to emerge from this sector. Once

they were in the bag, would the same incentive still exist to explore all the relatively minor situations that one should?

The early material proved very encouraging in fact and was shaped into a rather novel and successful exhibition. A book is now planned to complete the whole project.

There is an engaging lightness of touch about this photography and a prevalent, subtle humour. It is a straight approach, without gimmickry, and sometimes one may fail to notice the complexity of an image because it falls together so naturally. A good example is the group picture taken at Tenby Point.

Foreground, centre and background, all have strong areas of interest but none dominates the others. The figures at the left are very busy but the composition within this section is well controlled and as a whole it balances with the stationary but prominent shape on the right.

The sheep playing at sentry duty are on an artillery range at Epynt. The swan lends an even more incongruous touch to a pond on a Cardiff housing estate. It doesn't need the actual presence of people to record a great deal about their way of life.

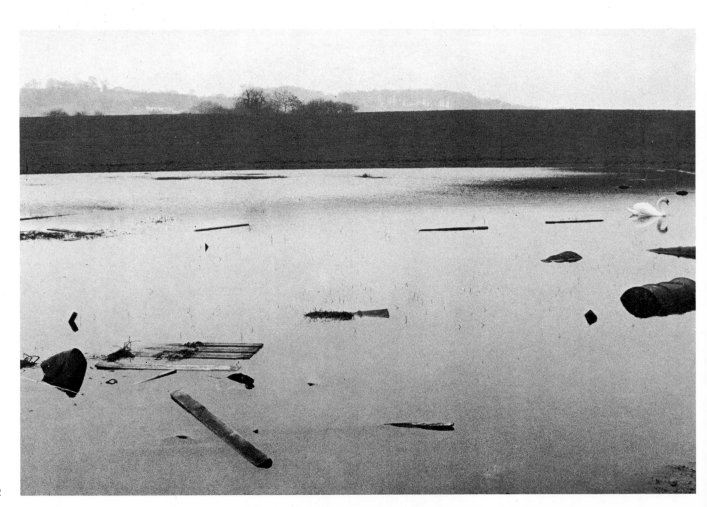

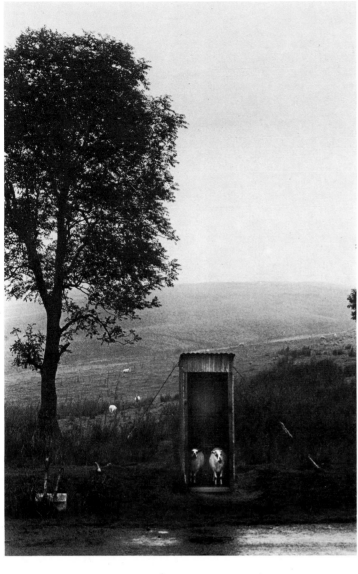

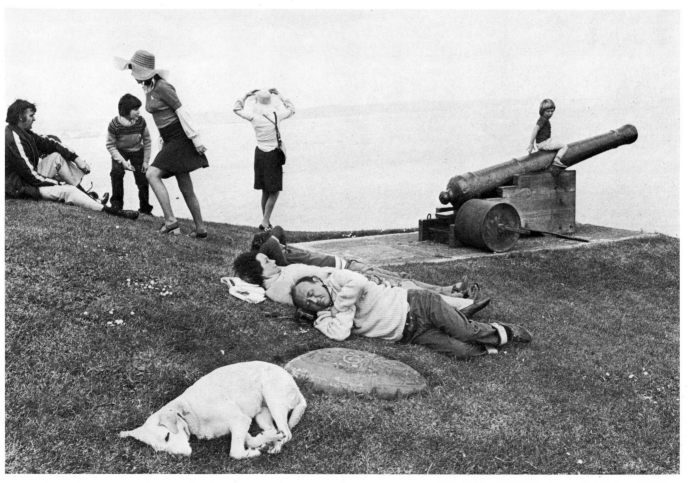

At the highest level photography is not a vocation but an obsession. There is no clearer example of this today than the work of Josef Koudelka.

These pictures are from his book 'Gypsies', published in 1975 but largely photographed between 1962–1968 in the Gypsy encampments of Eastern Slovakia. This book is just a small fragment of Koudelka's documentation of the life of these nomads throughout Europe.

Whatever the inconvenience or hardship, he lives and travels with them, returning time after time to improve his coverage of their most important gatherings. Nothing distracts him from the most single-minded pursuit of his work. After one knows Koudelka for a time, one uses the word 'dedication' with a new respect.

The photographic approach is strictly simple. No gimmicks. No set-up situations. No interference with the action. No unusual viewpoints. No extravagance of equipment. Just two 35mm cameras with standard and modest wide-angle lenses.

The images that result from this ascetism are as rich as they are honest, a fine combination of documentary and aesthetic values.

Photographs by JOSEF KOUDELKA

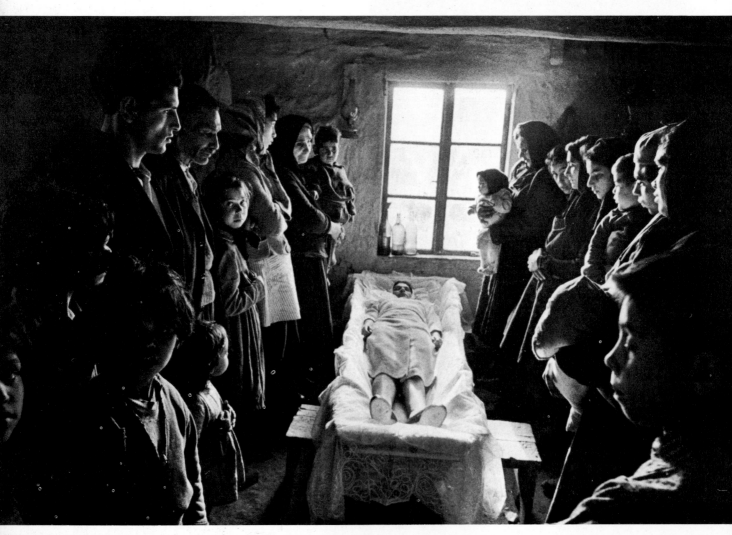

Photographs by
ABIGAIL HEYMAN

Abigail Heyman anticipated Don McCullin's words. In the introduction to her book 'Growing Up Female', she explains that it is about women and their lives as women, from one feminist's point of view. Then she adds, 'This book is about myself'. That is the truth of it. One might well argue that all photography at this creative level is as much a revelation of the photographer as a description of the subject.

The simple structure of these images adds to the directness of their appeal and they show a rare quality of empathy. What other medium can communicate the details of life with such freshness and vitality as photography?

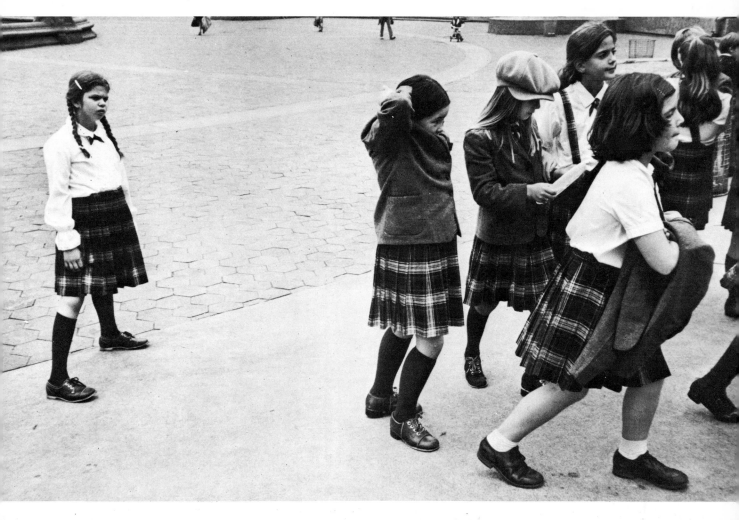
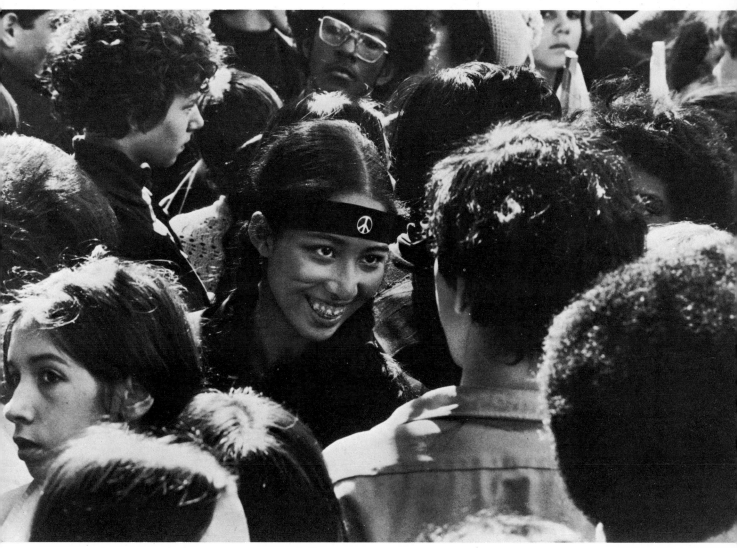

5 Urban landscape

Urban Landscape at one extreme could be a panorama of Manhattan and at the other extreme, a set of traffic lights. It is the man-made environment in which we live, whatever its individual scale, both the general scene and particular detail.

Within this comprehensive framework, several increasingly well-defined, specialised enthusiasms have established themselves in recent years through photographers of highly individual talent like Lee Friedlander, Ralph Gibson, Lewis Baltz, and others. Their influence has been enormous and not simply within this one field.

They used the urban situation to investigate and express ideas that were more complex than merely a superficial description of their surroundings. They were very much part of the intense exploration that was underway into the nature and potential of the photographic image. They also brought with them a certain wit and a gift for irony.

They were curious about the way objects in depth were reproduced on the flat surface of a print and the extent to which that illusion could be concealed, revealed or confused. They rediscovered old interests in texture and in the minutiae of appearance. They rejected concepts of romantic mood, observed the contemporary scene clinically, though sensitively, and recorded it with clear precision.

Later there was an upsurge of interest in colour photography, with a noticeable move away from the expressionism of previous work. But there is still a conflict between those who use colour for its own sake and the opposite school to whom colour is an integrated part of a whole experience.

DAVID PLOWDEN

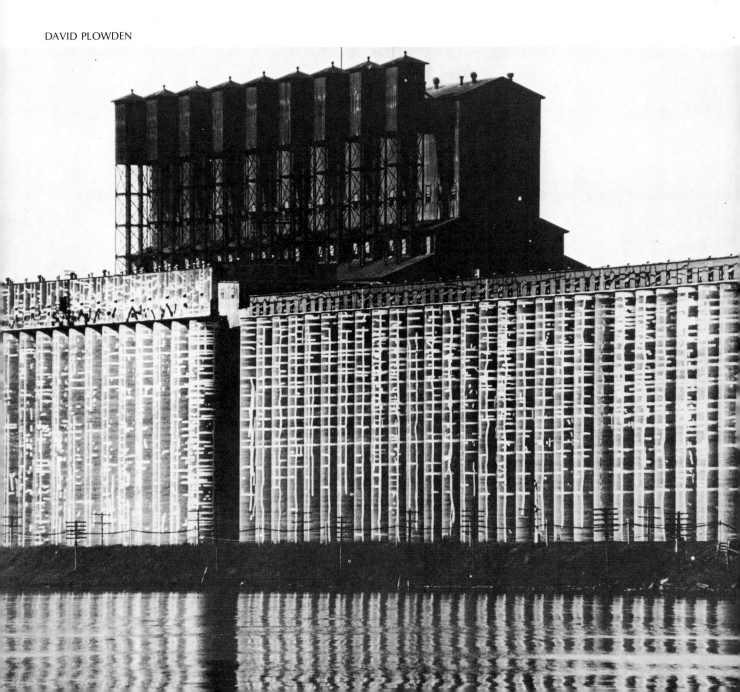

Both literally and metaphorically there is a world of difference between the relationship of Man and environment in Burk Uzzle's picture, overleaf, and in Bradford Washburn's opening photograph of Chapter 2. The contrast is marked and illustrates one strong tendency within the Urban Landscape theme – both implicit and explicit criticism of the man-made scene.

In both photographs, the figures serve primarily as elements of design and to give scale. They are not intended to have any personal identity. In the Uzzle picture, they suffer an extra weight of anonymity, they are ciphers within a structure. The mood is open and even uplifting in the Washburn image. The reverse is true of the other picture, where the surroundings are claustrophobic and sinister. Even the light is strangely flat and shadowless. This suggestion of people reduced in vitality and significance by their environment is characteristic of Burk Uzzle's work in this area.

Architecture is a prime subject within the urban theme and the obvious masterpieces get their fair share of attention. But perhaps we are surprised by photographers who turn their attention to industrial constructions or to plain, even ugly suburbs.

David Plowden's photograph of a grain elevator is from his book, 'The Hand of Man on America'. He says in his Preface that it is an attempt '. . . to show on the one hand what we are capable of and on the other what we are doing.' The strength of the full image and the curiosity of the detail explains his choice of subject.

Is Robert Adams saying that this suburban street in Denver is beautiful? Probably not. He is simply describing it but describing it well. Notice the height and angle at which it was taken and how this relates the street to its setting far better than a ground level view. This is a street in Denver. This is the way it is.

ROBERT ADAMS

Photographing a Nash terrace or a Gaudi cathedral, the problem is how to do justice to the inherent beauty of the subject. It demands an understanding of what has been achieved and the technical skill to communicate it.

If one is successful, the result is a sympathetic record of someone else's accomplishment. It takes similar skills but a different degree of perception, to create a beautiful image out of a tin shanty or an alleyway.

Both these photographs show that quality of inspiration, though their underlying philosophies are quite different. Also in both cases, it is the interplay of light and materials that gives the subject its exceptional appeal. Our recognition of how unattractive these materials normally seem, adds to our surprise and enjoyment.

In the Walker Evans' picture, for example, a cold eye would note a large shed built from corrugated metal sheets, with a crude sign outside, fragments of old posters on one door, and small heaps of sand, bricks and bits of rubbish all around.

On the face of it, not the most stimulating of subjects. And Evans was the last man to

want to transform it through any imaginative use of technique. His approach was austere in the extreme, documenting the subject objectively and precisely

Since it was just the facade that interested him, as was often the case, the camera was set up absolutely square to it, with no attempt to introduce any sense of drama through an unusual viewpoint. Then the image was strictly composed, eliminating any unnecessary elements. Evans did not emphasise any particular area of the picture by selective focus or exposure. Overall sharpness gives maximum information.

Bearing in mind the subject, it may sound like the recipe for a very dull photograph, but just the reverse. It is vibrant with light and as one scans it, the tiniest detail suddenly grabs the attention. For instance, the way the scraps of poster break up the insistent vertical pattern of the alternating lines of highlight and shadow. Dents in the metal sheets have the same effect and the nameboard with its lettered curves and angles stands out like an eccentric interruption of a determinedly rigid design.

The conscious understatement of Walker Evans' work often conceals a surprising sensuousness.

WALKER EVANS

There is nothing restrained about Bill Brandt's photograph. It is characteristically bold, and conspicuously an image rather than a reflection of reality. No photographer flirts with melodrama more outrageously or more enjoyably. This shot of a cobbled lane in Halifax, is a good illustration of his technique. Incidentally, the proper description of such a path, apparently, is a snicket – a rare word and one to be savoured.

The strong back-lighting reflecting brightly from the cobbles, the hand-rail and the top surface of the wall, is dramatised by the low camera angle and the extremes of tone. Minimum exposure helped lose the superficial shadow detail and printing on a high-contrast paper did the rest, with certain judicious 'burning-in' where necessary. The result is an overall shape imposing enough to balance the thrust and detail of that wedge of cobbles. Undoubtedly, the definitive image of a snicket.

BILL BRANDT

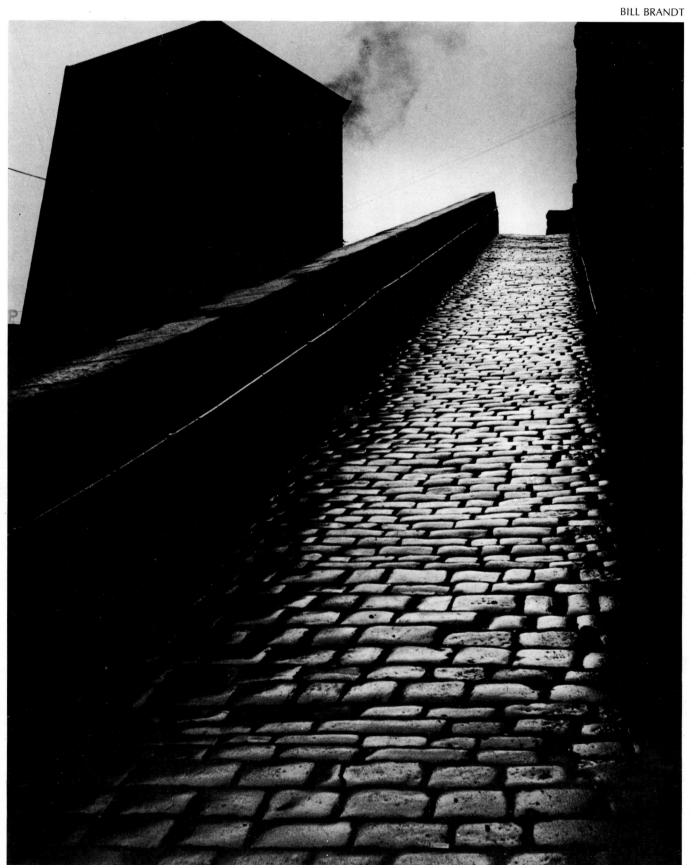

In design terms, the roadside cafe in this picture by David Plowden is a mess. But it is a fascinating mess. One gazes almost with awe at that confusion of form. Probably this is an eccentric personal reaction and one should really feel more dismay than amusement. The photographer's own full feelings about this place are not on record but, as was mentioned earlier in the chapter, he is generally appalled by the 'increasingly dismal condition' of the man-made environment. His urban landscape pictures are intended as an explicit commentary on the triumphs and disasters of the American scene.

Joel Meyerowitz makes it equally clear that his photographs are not intended as social documents. The appeal of a subject to him is mostly on a sensual level. He is attracted by qualities such as shine and flatness or by nuances of colour. But he stresses that his pictures are not primarily *about* colour, they are simply *in* colour.

The distinction is an important one. For him, colour is one element in the description of a subject and not of isolated, total interest in itself. He says, 'There is more to know and more to see in a colour photograph. In a sense, it has more content than black and white.'

DAVID PLOWDEN

The previous photograph by Joel Meyerowitz was taken on 10 × 8 in. colour negative film. But earlier he worked with a 35mm camera and wide-angle lens, documenting street life in New York. With black and white film he could expose on a sunny day at a thousandth of a second at f8 or f11. Virtually everything was in focus and with the fast shutter speed he could catch any gesture or incident.

But colour was becoming increasingly important to him as a means of description and with the slow colour film he preferred, it was not always possible to obtain overall sharpness and still capture the same split-second action. He changed his approach and held off from his subject. He was no longer concerned with particular incidents, about one subject within a frame, but with the entire frame.

'I began to see right down the street, rather than just the plane of an image 10 ft. in front of me into which some action errupts for a moment. The street is like a stage comedy, you never know what's going to happen, people are always plunging in from the wings. As you step back you see the whole procedure, you see the wings, you get a chance to see the deep space of the theatre. I find that I'm being told things about human behaviour that I hadn't known to look for in the past. What does the photograph describe? It describes everything in it. It is about a totality and not just about an event.'

Sometimes Meyerowitz talks of his pictures as non-hierarchical, everything in them being of equal importance. In this photograph, he is as interested in the pink of the skirt as in the speckling of Christmas lights in the trees; in the red of the flag, as much as in the evening light. Incidentally, he used a small electronic flash to boost the foreground a little.

The name of Ernst Haas keeps appearing throughout this book. It reflects his pre-eminence in colour photography and also his surprising range. The urban landscape has been one of his constant preoccupations. Like the Plowden picture, his image of visual pollution is as intriguing as it is lamentable. A telephoto lens emphasised the density of detail and the colour stands out with lurid intensity against the dark background and clouds.

The other Haas picture looks like a composite image but is actually a single photograph of the reflections in the revolving door of a New York bank. It is taken from his book 'In America' and his picture caption reads, 'Only as a photographer can one preserve this perfection of overlaying images in compositions that hold together of themselves.'

JOEL MEYEROWITZ

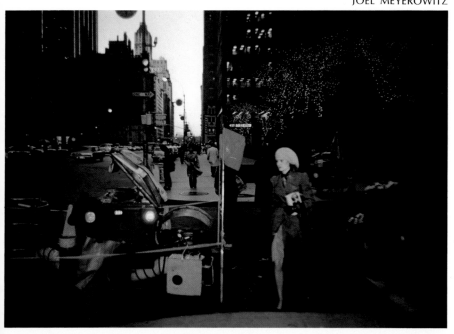

ERNST HAAS

Many of Ernst Haas' photographs hint at abstract form but remain firmly rooted in the detail of reality. This is well illustrated by his pictures of reflections, such as the one overleaf. An even more obvious example is this image of torn posters, a study in shape, colour and texture.

The original subject-matter of some of his pictures may seem banal or even ludicrous, mere urban debris, but he gives them a new visual dignity and excitement. Sometimes he finds similarities of pattern between the most unlikely combination of objects, creating an added surprise.

Aaron Siskind's picture is also of a wall surface. It is *of* flaking paint but that is hardly what it is *about*. Its real concerns are essentially photographic, they are about the qualities of light, detail and design that can be expressed through the black and white image. It is also about whatever the viewer wants it to be about. An image of this kind is wide open to personal interpretation and visual association.

Then one has to circle back to the point of departure. Whatever else it becomes, the image is still of a patch of flaking paint, it is not wholly abstract. And the fact that we recognise it, sharpens our pleasure, because it makes us more aware of the potential range of our own experience.

ERNST HAAS

Ralph Gibson's photograph is so simple and the subject so apparently banal, that it is all too easy to reject it out of hand as inconsequential or pretentious. If one approaches it more openly, it offers very genuine, if subtle, pleasures.

The quality of texture is interesting both in general effect and in detail. Compare the crisp boldness of the vertical line set against the black, with the crumbling edges of the concrete grooves and the delicacies of tonal gradation.

There are no clues as to the scale of the construction but the image is so strong that it encourages one to think of it in quietly heroic terms. It doesn't matter what the subject actually is, the image itself suggests the monumental.

Whatever drew Ken Josephson's attention to this small patch at the bottom of a wall in Istanbul? Nothing awe-inspiring about it, just a tiny detail, a modest, amusing, little surprise. What strange texture. And did those twigs really scratch out those marks on the wall, sweeping across it like windshield wipers? Curious.

Graffiti range from the objectionable to the hilarious but was there ever one more full of pathos than those two words, 'I need', recorded by William Klein? The written word plays a number of roles in urban life, informational, entertaining and decorative.

KEN JOSEPHSON

ELLIOTT ERWITT

ROBERT FRANK

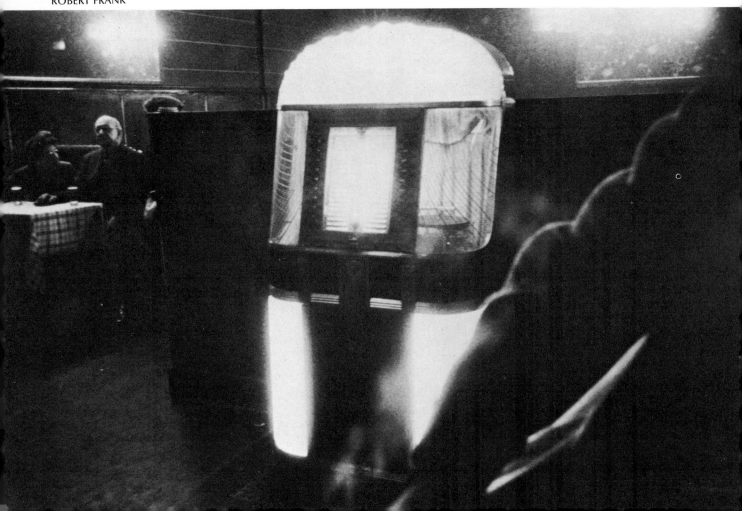

The urban landscape also extends indoors, giving a fresh range of interests and picture opportunities.

Elliott Erwitt's venture into the American Interior resulted in this classic image from Miami Beach. The room surely defies verbal description. With a subject like that, no other frills were necessary, just a straightforward record shot. But it should be noticed that it is a neatly composed one.

Below it, Robert Frank's photograph is also essentially a visual experience. The juke-box is alive with light. It has an almost menacing aura of energy, like some alien spaceship in an early Hollywood movie.

Explaining the effect seems rather crass in a way, like spoiling an illusion, but to be practical, it was caused by allowing the over-exposure of the bright part of the subject. This created a halo around it and bleached out any detail, giving a solid white.

The seemingly careless composition, with the obstructive foreground shape, adds to the feeling of uncontrived, spontaneous observation. Frank helped to pioneer the move away from the elegant documentary image, sacrificing beauty of form in order to achieve more directness and urgency of expression.

His pictures of objects like juke-boxes, motor-cycles and TV sets, also helped to open up whole new areas of subject-matter for photography. He made clear both their pictorial and their symbolic possibilities.

Reflections and window views have always been popular photographic subjects but never more so than in the last decade, probably because of the growing fascination with images that were not quite what they seemed. It was all part of a major trend towards greater ambiguity of description.

Raymond Moore's photograph is richly descriptive but that in no way lessens its fundamental mystery. The surface of the curtains is detailed wrinkle by wrinkle. But what really arouses our curiosity and creates the mood of the picture, is the interplay of that detail and the half-seen shape of the building beyond. The section clearly visible between the curtains makes an effective tonal contrast and also introduces some clean outlines as a foil to the rest of the image.

RAYMOND MOORE

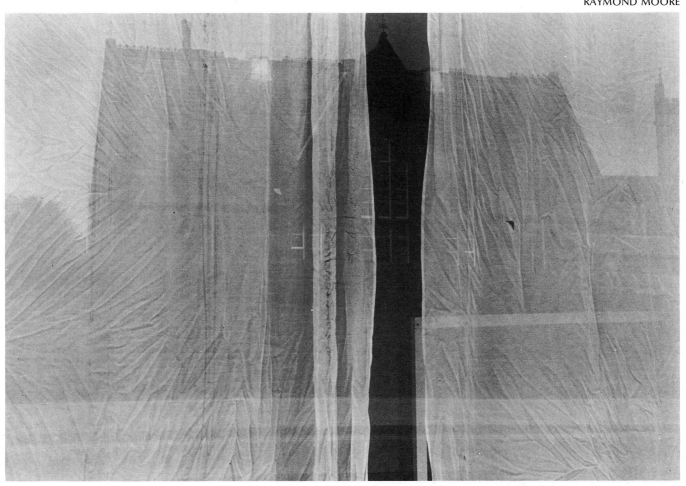

Lamp-posts, traffic lights, telephone wires, bus-stops, kiosks, parking meters and so on, are the street furniture of our cities, the environment of most of our lives. But until recently we did our best to ignore them, to shoot around them, they were visual obstacles. Today, half a generation seems to photograph little else.

Lee Friedlander is as responsible as anyone for this enthusiasm. He once declared his interests as people and people things, and he has recorded this urban detail with cool objectivity and wit.

Statues have always been 'acceptable' subjects but Robert Doisneau has long used them as the butt for his irreverent humour. They also fascinate Friedlander who has produced a book on American monuments.

Who would ever have believed it — a romantic picture of trash cans? But Ikko made it work. Probably a filter helped to darken the sky and accentuate the clouds. The viewpoint makes the most of the dramatic lighting.

ROBERT DOISNEAU

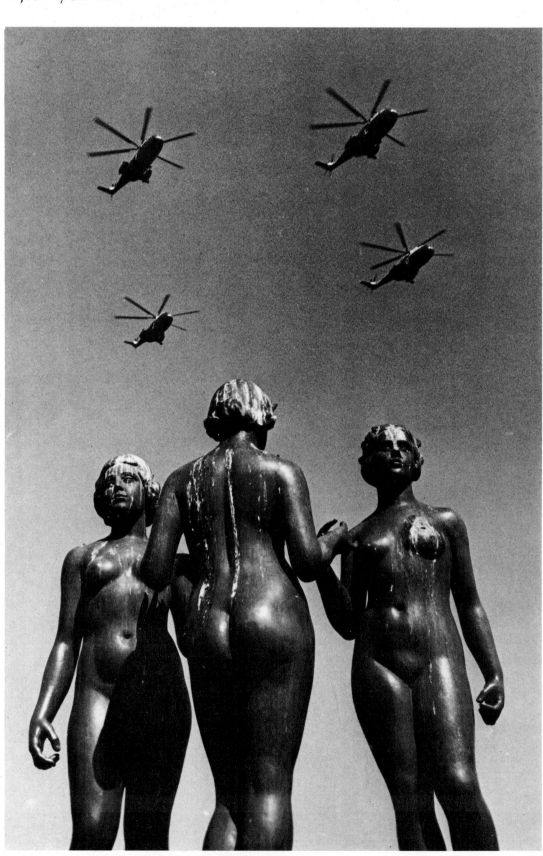

LEE FRIEDLANDER

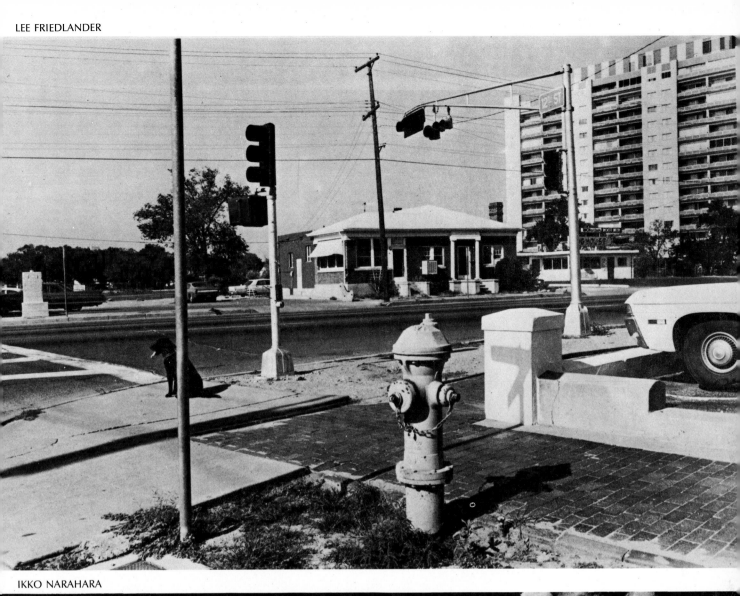

IKKO NARAHARA

The car and everything involved with it, roads, signs, garages, parking meters and so much else, is an immense theme in its own right within the urban landscape.

It has been photographed from every conceivable angle and with every imaginable intention. But Robert Frank can still show it to us again with a fresh sense of mystery and visual excitement.

The quality of light on the covering sheet; the peaks, folds and curves of the material; the way it seems to hang suspended over the dark surface of the road; the faint traces of the concealed shape; the contrast of practical, urban detail and the flamboyance of the trees; without any tricks, the photographer makes us aware of the extraordinary in the commonplace.

Revealingly, the photograph on the left by Burk Uzzle was used on the cover of his book, 'Landscapes'. It has a striking, graphic quality, the strength of the design being emphasised by the tonal contrast. As in so many of his pictures of the urban scene, one feels that the man-made environment, if not actively hostile, is forbiddingly inhospitable.

The relationship between Nature and townscape is visually a very profitable area for the photographer to investigate. Obvious possibilities would be the contrast between manufactured and natural forms, or how natural elements, such as trees, are used in an urban context.

We have already seen in the Robert Frank picture how their vitality can dominate their setting. At the other extreme, they can symbolise uniformity and inhibition.

Lewis Ambler uses them as part of a complex composition in line, tone and texture. It is a photograph that depends for its full effect on being carefully read. Its pleasures are quiet and refined.

Notice the geometric pattern formed by the central vertical line of the picture and the angles of the trunks. And how the slimness of the tree and its thin, black shadow across the lawn, changes in tone and shape against the wall. Or look at the texture of the bark and how it reflects light like a polished mosaic.

Perhaps photographs of this kind are an acquired taste but it is one worth cultivating.

LEWIS AMBLER

People have not been prominent in this chapter, since it is more concerned with the stage, as it were, than with the actors. But there is no shortage of chances in urban life to relate the two elements in a variety of ways.

As we have already seen, the human figure is a very convenient reference for giving scale to a picture. And it is incredible how small it can feature in an image and still dominate it.

In Bob Kauders' photograph of a steel-works at Scunthorpe, the cyclist is dwarfed by every object around him. But his irregular shape silhouetted within another bold form, draws the eye irresistibly.

Studying the print, one can see how skilfully the photographer has retained the tonal separation even among the mid to dark greys. Since this is an image which creates such an immediate impact, these subtleties may seem irrelevant. But this quality of delicate gradation is unique to photography and can bring a fine sensuous satisfaction.

With a photograph like this by Lewis Baltz, one has to settle down for a good read. It is not obscure but neither is it an instant experience.

Tune yourself in by noticing all those rectangular forms – the outside frame of the image itself, the large box shape on the right, the bricks, the ladder, the door, the strips at the far left and the base. See how those forms are also broken up into further rectangles – the frame and panels of the door and above all, the ladder. Some of the forms have depth, some are flat. Some horizontal, some vertical. There are differences of tone and varieties of texture.

Look how they balance, how they are linked by other geometric shapes and how the symmetry is relieved by patches of eccentric form and irregular tone, as on the rear wall. Look how the stack of bricks ranges so accurately with the back of the platform and how the rest of that space is broken up by the lengths of wood. Look at the visual surprise of the curves of the ladder rings. It is a picture that repays attention.

LEWIS BALTZ

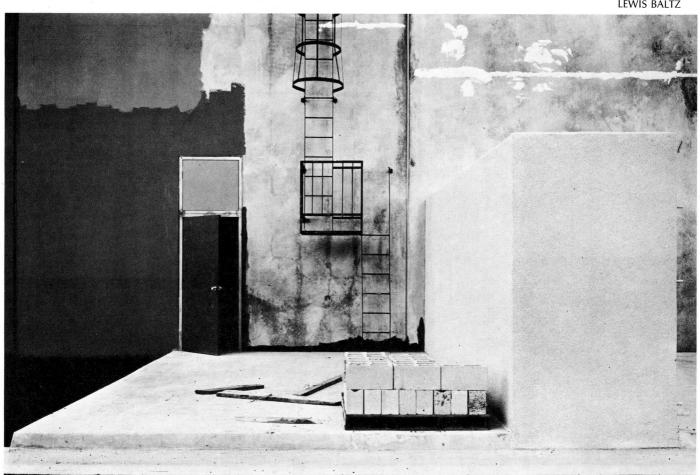

Photographs by CHRIS KILLIP

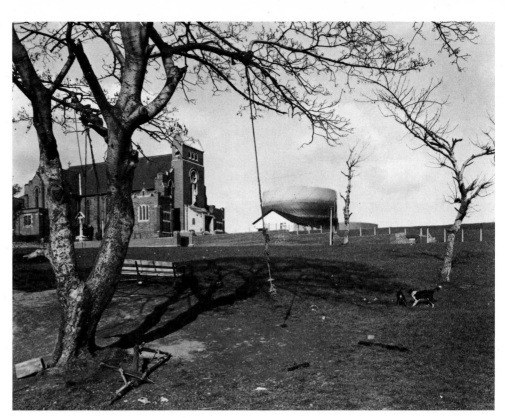

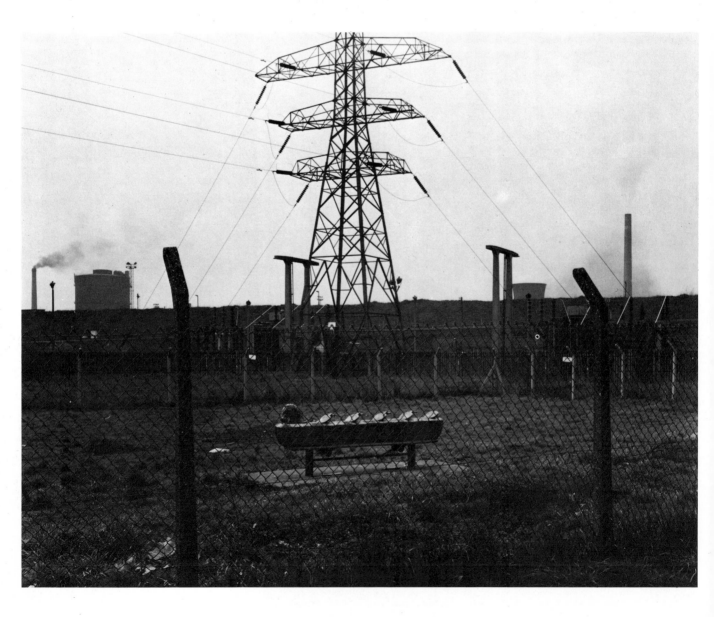

It was the urban areas of England that most interested Chris Killip when he decided to photograph here. It was the very contrast with his rural background and having worked for so long in the landscape of the Isle of Man. Sometimes his pictures, like the one below left, seem to reflect social documentary interests and there are obvious areas of overlap, but his principal visual concerns are photographic.

He uses a large-format camera and enjoys its ability to record such a wealth of cumulative detail. He also feels that it encourages an objective approach to the subject, creating a discipline of studying a scene very carefully, both directly and on the plate-glass, before making an exposure. The quality of detachment in his work is important to him. He wants his photographs to retain a certain ambiguity and understatement. They are involved with description and not with drama.

Similarly, he does not exaggerate tone but brings out the full range that is possible with the large negative. This is conspicuous in the snow picture where many photographers would have heightened the contrast in order to emphasise the composition. The people in this image are seen primarily as elements of design but neither they nor their background are reduced to simple abstract form. One can respond to them on several levels.

The last picture illustrates a basic problem for the photographer working in an environment of this kind. As Chris Killip himself expressed the dilemma, 'How to make an order out of a disorder and yet retain the idea of that disorder.'

It is very much a photographic challenge. He noticed the scene when he was driving past and he couldn't resist trying to take a picture there, to make something of all the various elements. It was largely a question of instinct but it led him to keep going back there for a couple of days to get to terms with it. Like the Meyerowitz picture earlier, the resulting image is not built around a central subject. It is about everything within the frame, it is about the balance of disparate factors and their description.

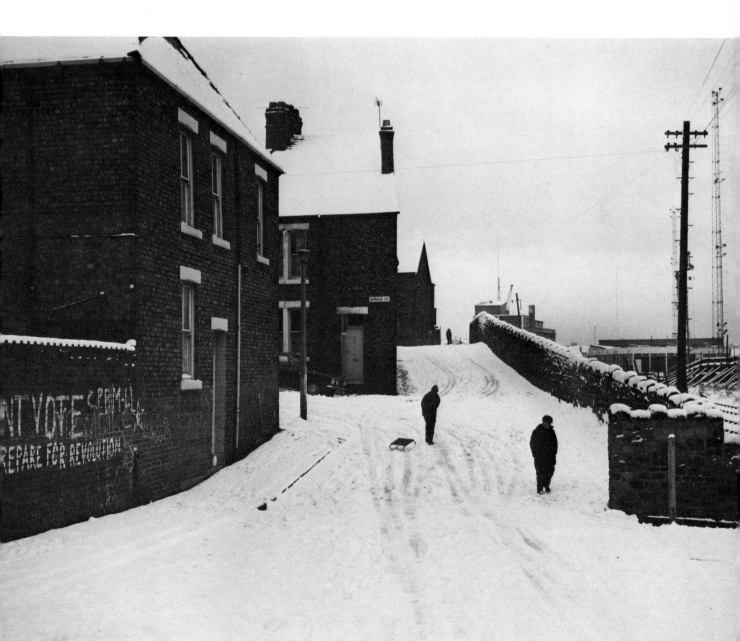

The image

The Image may seem a somewhat comprehensive title for a single chapter, since all photographs are images. But it is a simple way of emphasising that in these pictures the narrative content is minimal and the visual qualities predominate.

The purer their visual appeal, the more difficult they are to discuss. They communicate outside the wave-band of verbal expression.

The first five photographs make this very obvious. Each is a quite unique image and beyond complete analysis. One may be able to suggest certain clues as to their effect but their fundamental mystery is absolute. They are magic. They are also very rare. One cannot just go out to take pictures like this. They happen to you.

The other photographs, very special in their own way, are more conscious explorations of image structure. They are particularly concerned with elements of illusion, how a three dimensional subject is translated into two dimensional terms and the opportunities this creates to make use of visual paradox and ambiguity.

This fascination with the vocabulary and nature of photography and a heightened awareness of the differences and possible interplay between object reality and image reality, is one of the most marked current obsessions.

It is all part of the drive to improve the flexibility of the medium as a vehicle for personal expression, part of the continuing reaction against the documentary function of photography and a move towards achieving a greater degree of interpretive control. The creative possibilities become increasingly varied and complex.

MARIO GIACOMELLI

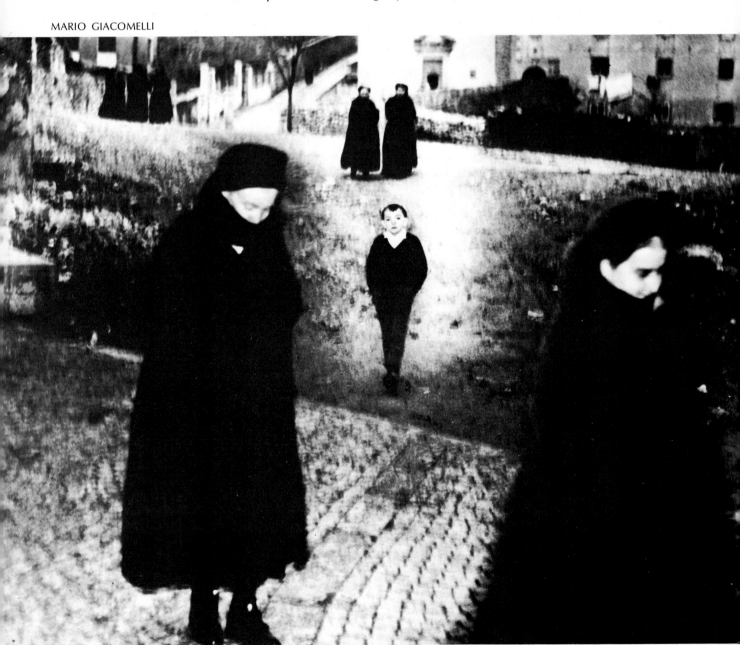

The opening photograph by Tony Ray Jones, taken at a Butlin's holiday camp, is enjoyably enigmatic. One day it seems amusing and the next, rather sinister. Superficially, one can probably explain what is going on; a spectator peering through the observation window of the swimming pool and a swimmer staring back. But the image is so much more evocative than that.

The confrontation between the two men is disturbing partly because of the pronounced two dimensional effect of the window. The detail is applied to its surface and because of the blank expanse of water, nothing suggests any sense of background distance. The window could well be a painting. This interpretation is encouraged by the extravagance of the mural decoration that already exists. The spectator too, almost a silhouette, seems to merge with the pattern.

The most difficult thing to understand is the sub-conscious disquiet that this picture creates in the reader. Is it simply a result of the disorientation caused by the confusing visual information? We still treat a photograph with such credulity. No wonder we can be so unbalanced by its basic qualities of illusion.

The power of Mario Giacomelli's picture, left, is even less explicable. The grouping of the figures around the boy is obviously curious. The women are so withdrawn and sombre. Surrounded by them, the boy is so casual and yet so vulnerable. The whiteness at his throat is such an open element in an image dominated by shapes of solid black tone. The quality of light is most unreal. And even in an original print, the detail is sketchy and imprecise. The ultimate effect is more of hallucination than of record.

Romano Cagnoni's photograph shares this surrealistic uncertainty. There is something of the marionette about the pianist and the feeling of unreality is enhanced by the sensation that the figure is floating in space. It has no clearly visible support and the background looks like mist or cloud. Curiouser and curiouser.

ROMANO CAGNONI

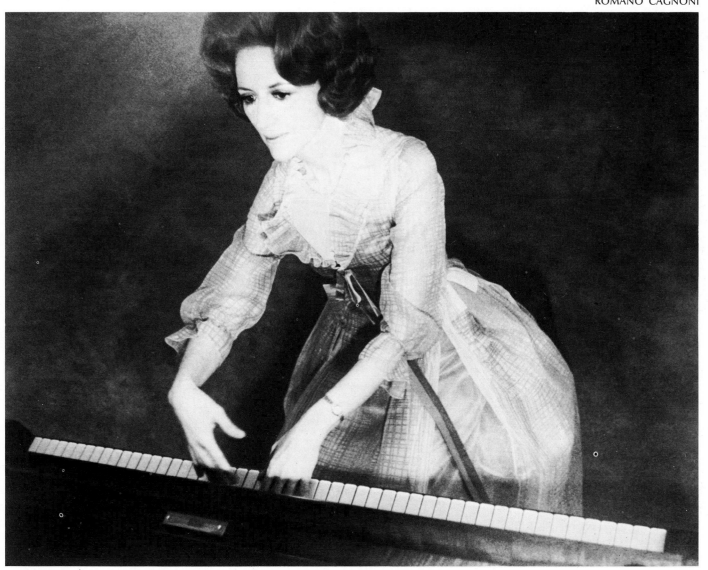

There comes a point in discussing photographs when further explanation may be useless to help someone else enjoy a picture. It is a question of individual reaction and one's response to images is as uniquely personal as one's sense of humour. So the pleasure of these two photographs is doubly difficult to communicate. But if it can only be shared instinctively, perhaps so much the better.

It is fascinating to hear other people's reasons for enjoying a photograph that is one of your own personal favourites. The Boubat picture is a good example.

Their appreciation is sometimes tinged with fantasy and sometimes more intellectual, all to do with the apparent visual contradictions of the image. For instance, how can a tree in such full leaf be standing so close to the wall behind? One's enjoyment doesn't depend on learning the answer,

not even on knowing the answer, but simply on being asked the question so entertainingly.

The pedantic explanation is probably either that the picture was taken with a long focal-length lens or that it is an enlargement from a small part of the negative. Both would create the illusion of compressed space (see page 26).

The Erwitt photograph encourages more whimsical interpretation. Why on earth *is* the little dog a few inches off the ground? And how did the photographer catch that moment? One looks at the other objects that loom large in the picture, searching for clues, trying to fill in the story. But the mystery only deepens. Ask Elliott Erwitt himself for an explanation and all he does is smile a smile, as enigmatic as the image itself. And of course he is so right.

EDOUARD BOUBAT

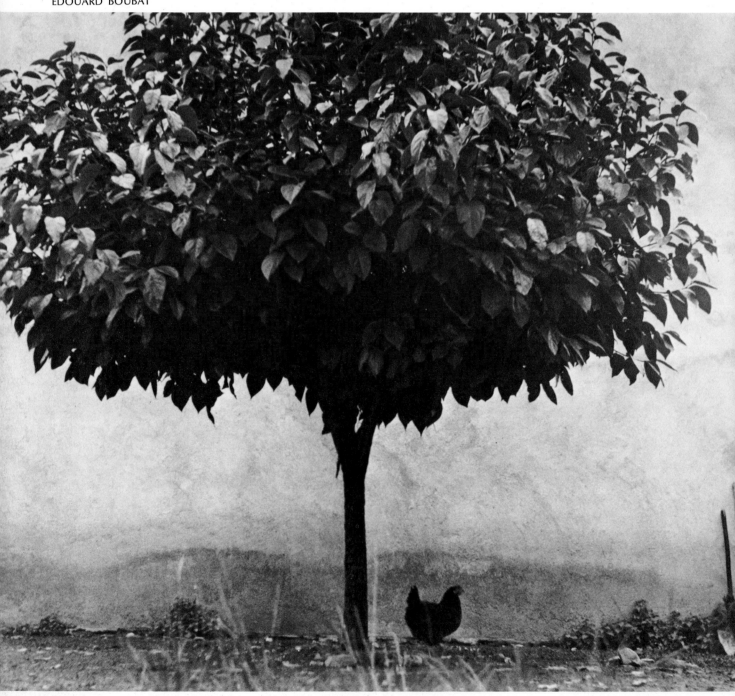

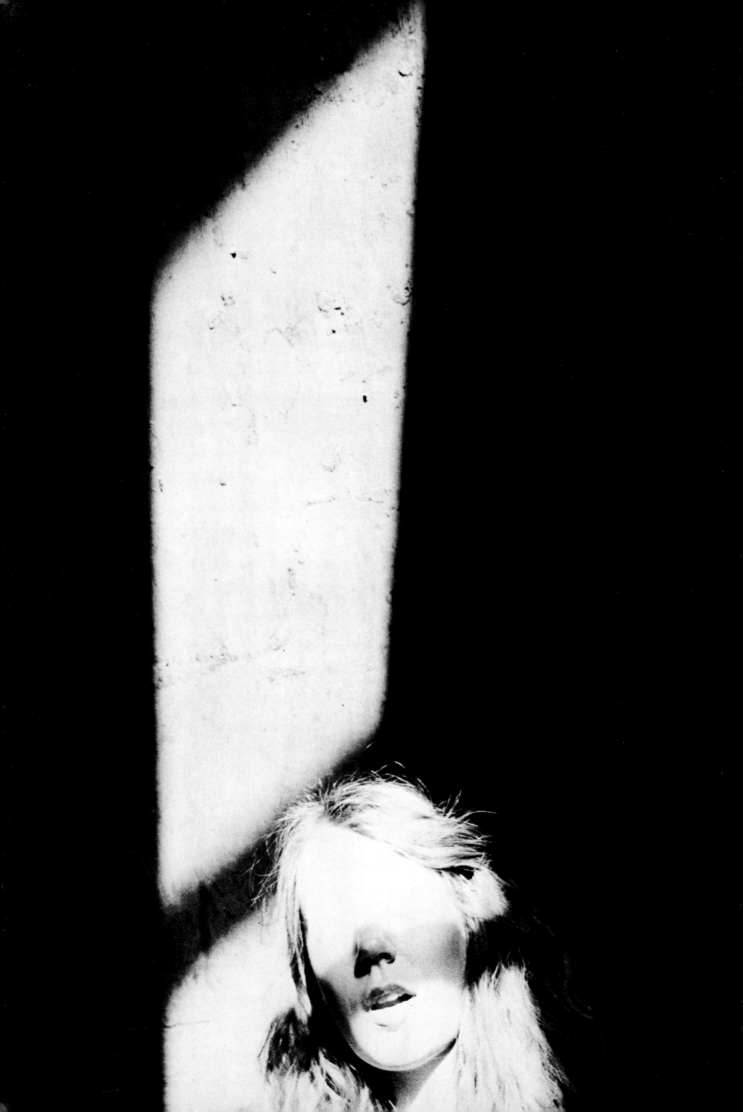

The illusive qualities of the medium are a major preoccupation of many photographers today. They are keenly aware of the visual elements that affect how we instinctively interpret images and they use this knowledge either simply to make the illusions obvious or to create more complex pictures.

The work of Paul Hill illustrates particularly well how an increased understanding of these elements can fundamentally influence one's photography. In just a few years his photography has acquired a fresh excitement and a real authority. His pictures are partly intellectual explorations of visual ideas and partly the reflections of very personal and profound psychological feelings.

Some readers may feel rather sceptical about this last claim but look closely at the photographs, especially the last three. They are too disquieting to be mistaken for simple records of rather insignificant events. It is not necessary to define these feelings precisely. Their effect like their origin is largely sub-conscious and very much a matter of individual response. But they do communicate themselves and they are a consistent force in Paul Hill's work.

Photographs by
PAUL HILL

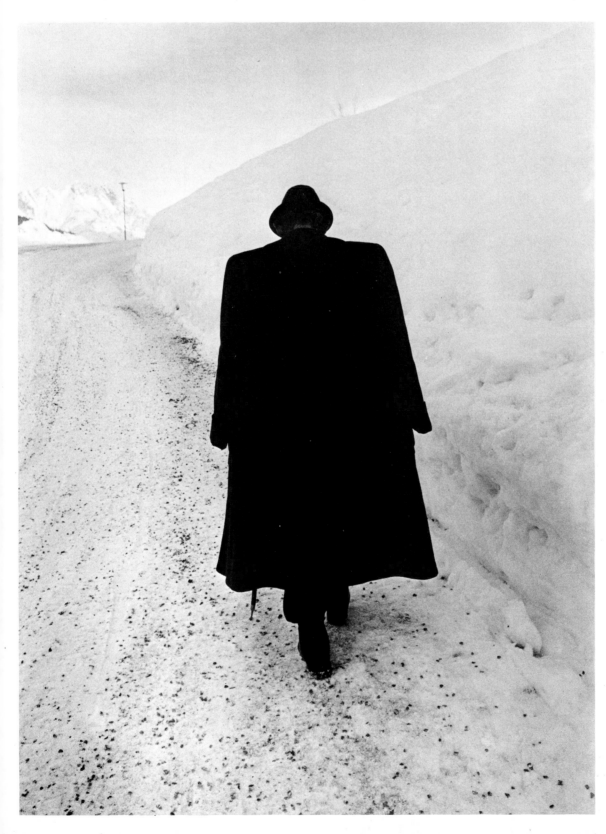

The ideas that interest him are easier to analyse. The first picture, page 128, results from his initial enthusiasm for enquiring into the basic nature of photography. It is about light and the different ways that the eye and the camera react to it. The eye instinctively accommodates to its intensity; more deliberate adjustment is necessary with a photograph.

As Hill says, 'There is a person almost obliterated by light, by something as ordinary and mundane as light coming through a window. It was a revelation to me to explore the medium in this way.'

The next picture is also relatively straightforward, showing an awareness of shape and the tonal strength possible in a black and white image.

The most marked feature of the two photographs on the right is how they make use of the relationship between the subject and the picture frame. It is not just a question of how much of the overall scene is included but precisely where the edge of the frame is placed. (See also page 16.)

In the top right picture, the edge chops off the little girl at knee level and cuts right through the eyes, which psychologically is even more disturbing. This visual tension adds strongly to one's sense of the child's vulnerability.

Similarly, the main point of interest in the lower picture is deliberately squeezed into the corner of the frame. It emphasises that one is looking at an image, that the photographer is manipulating the situation. Paul Hill explains, 'I am not providing a window on the world. I am trying to hold a mirror to my own state of mind.'

The picture above is fascinating on so many levels. Superficially, it is of someone with their head through the hole in a cut-out figure, the sort that seaside photographers use. But because of the angle from which it was taken, it becomes so much more ambiguous and complex. The way the image is divided down the centre, the strange faintly-seen background creatures, the sticks seeming to penetrate the head and body, the visual confusion of space and distance, make it a very mysterious photograph indeed.

Photographs by PAUL HILL

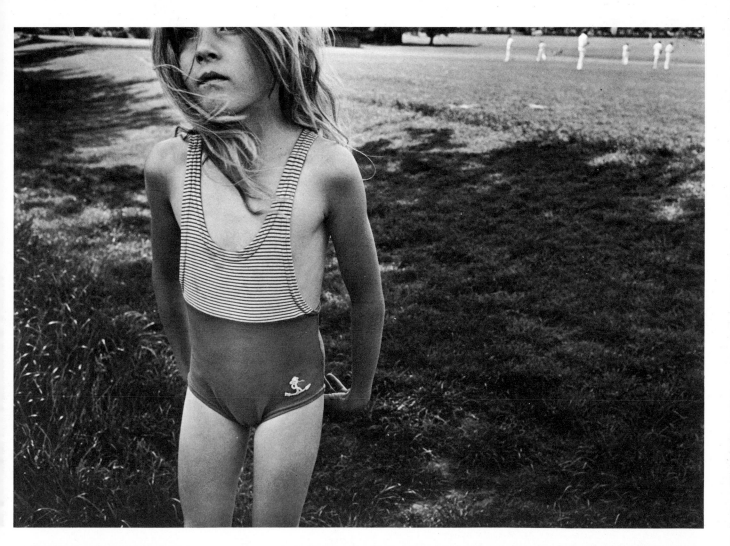

Photographs by JAMES WEDGE

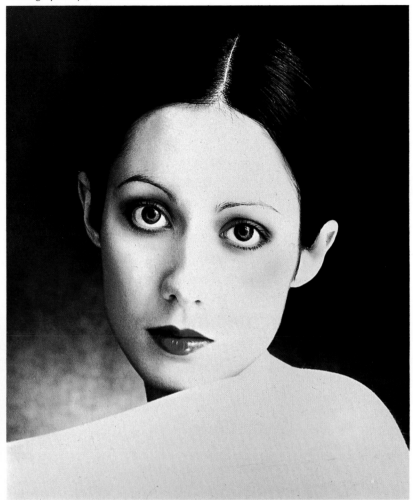

James Wedge's approach to photography has always been playfully iconoclastic. His imagination is not easily inhibited by convention nor discouraged by the apparent limitations of the medium. It is an obvious strength both of his private and professional work, in fashion, advertising and editorial illustration.

He makes use of existing qualities of illusion in photography and also happily takes quite radical liberties with the image. Notice the extraordinary two-dimensional effect in the picture on the left. The darker shapes of the steps stand out so clearly against the white background, that they appear vertical instead of horizontal and the feeling of depth is lost.

The other two photographs were not taken on colour film but were hand tinted. This skill gives him a degree of control he would not otherwise enjoy. It also has the commercial advantage of making his work different and distinguishable.

The portrait shows the dramatic value of locally applied colour contrasting with the high key monochrome image. Colour is also used sparingly in the pattern picture. The model was photographed in various poses and the results carefully arranged. Then the final print was tinted to bring out the design.

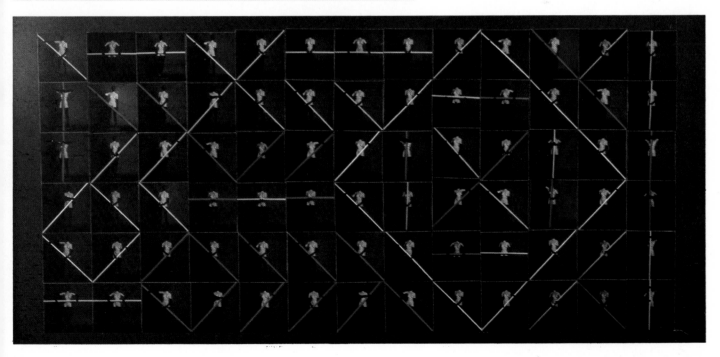

The unusual quality of Andy Earl's picture was produced by a combination of daylight, electronic flash and a slow shutter speed. He calculated the daylight exposure normally, then reduced it by one stop. The flash was synchronised with a shutter speed of 1/8th second. The camera was fitted with a wide-angle lens and loaded with colour negative film, giving a picture format of 6 × 7 cm.

The subject movement was frozen by the flash but a blurred secondary image was created by the general exposure. This is most visible in the background and around the edges of the main subject. There is a marked three-dimensional effect. The large format gives a smoothness of tone that shows the rich colour to advantage. The colour negative process allowed useful darkroom control.

Pierre Cordier explores the creative possibilities of chemistry in photography. In 1956 he invented what he calls the 'chemigram', describing it as, 'A picture that owes its existence to the localised action of chemical substances on a photo-sensitive surface, without the use of camera, enlarger or darkroom.' It is not a photogram of any kind; the process is basically chemical. An infinite variety of effects is possible through adjusting the combination of the three basic elements – the photo-sensitive materials, the localising substances and the chemical solutions. Understandably, he does not reveal his technique in detail. In 1963 he invented a way of combining photographic images and chemical process as 'photochemi-grams'. The example, right, is from his series, 'Homage to Muybridge'.

ANDY EARL

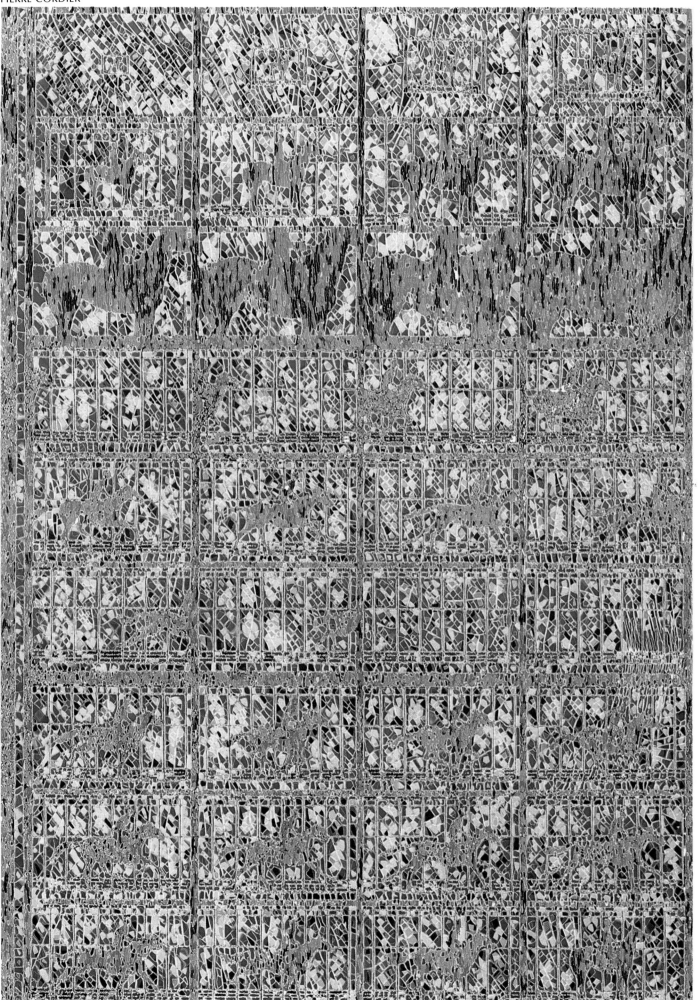

The conventional photographic approach is to record a subject within the frame of a single image. Sometimes, pictures are used sequentially, each being read in turn. Douglas Holleley experiments with constructions where a number of photographs can be viewed both separately and as part of an overall image.

In this montage, for instance, he created an imaginary landscape structure from Polaroid Land colour prints of slightly varying details. The instant picture process is convenient for this work because it makes possible immediate evaluation of both the individual image and the progress of the general composition.

Other pictures in this book encourage an imaginative reading – for instance, the Aaron Siskind photograph on page 109. But none are quite so determinedly ambiguous as this image by Minor White. The subject, scale and viewpoint are all uncertain. The picture mystifies, fascinates, amuses and, paradoxically, even satisfies, because it is so full of enjoyable detail and visual stimulation. One doesn't know what it is, but it is beautifully described. Minor White was a latterday prophet of the significance of metaphor in the medium and he preached the need for the photographer,' . . . to free himself of the tyranny of the visual facts upon which he is utterly dependent.'

DOUGLAS HOLLELEY

DUFFY

This Duffy photograph is marvellously out-rageous. One doesn't want to encourage people to trim pictures into fancy shapes but the rectangular format isn't sacred either. A dose of irreverence is a good occasional antidote for unthinking conform-ity.

The reasoning behind the picture was logi-cal enough. The subject was in a hurry to end the session and came to the edge of his seat. Duffy saw the image he wanted but couldn't get it all in with the lens he was using and he couldn't move back. He knew that once he moved the camera from his eye to change the lens, his subject would get up and call it a day.

With admirable presence of mind, Duffy quickly shot two pictures covering the top and bottom of the area he wanted to frame. There was no time to align the images neatly as he tilted the camera. When printed and matched up, this was the result. Duffy liked it and so he left it that way.

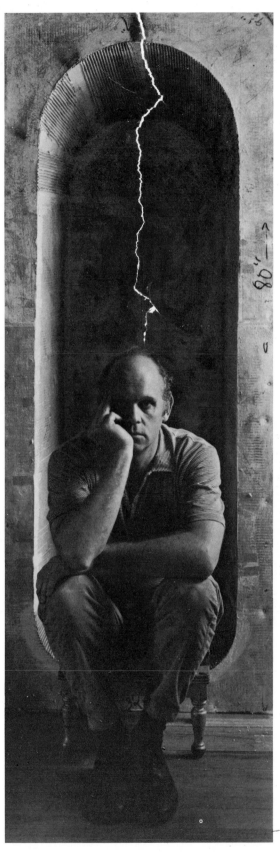

It takes a certain visual daring to tear a print in order to create a particular effect but Arnold Newman did exactly that with his portrait of Claes Oldenburg, right. The mark can be clearly seen running down to the sitter's head. Newman felt that the original picture didn't quite work, then suddenly had the idea to tear it. Visually it is intriguing and it echoes Oldenburg's own work which is full of humour and nonsensical things.

The other Newman portrait, of Andy Warhol, was conceived from the beginning as a collage. 'Andy is a rather bland looking man but like so many people in the public eye, he can suddenly put on an image. When I started to photograph him, he sort of drew up and widened his eyes. He wanted to become an image. So gradually I decided to use that.

'I photographed him that way, then bleached the image to make it starker, more like a mask. Then I thought of putting a mask around the mask in a frame and played around with several ideas until I wound up with this, one mask hiding another one and you never really get to see Andy Warhol.'

Photographs by ARNOLD NEWMAN

139

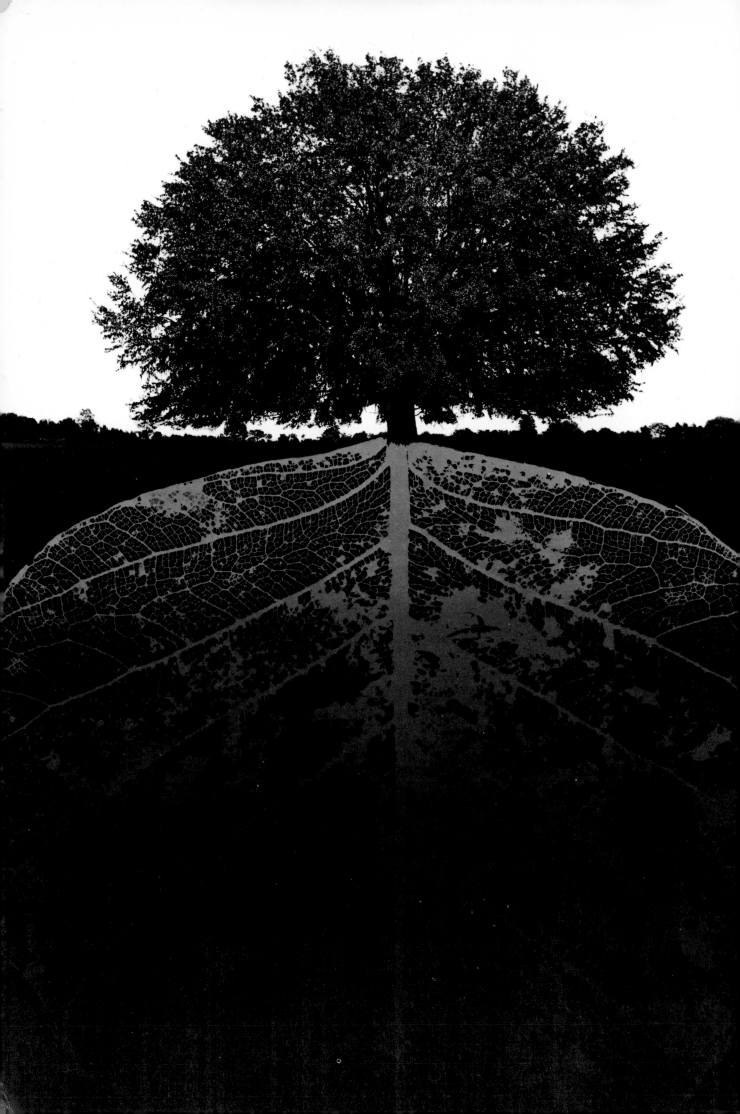

Even many people who instinctively mistrust heavily manipulated images, acknowledge Jerry Uelsmann's pictures as a special case. They are so skilful and witty that they disarm any but the most prejudiced criticism. For such a technique, they are surprisingly unpretentious.

The philosophy of the 'straight' photograph, the pure, untouched, uncompromised record, is still a major influence and it has much to recommend it. But today we are very aware of more ambiguous possibilities in the medium and therefore are more sympathetic to the interpretive or even experimental approach. Whatever one's personal direction as a photographer, hopefully one is also capable of appreciating work of a quite different character.

Uelsmann's pictures are produced by multiple printing. He blends several negatives into a single image on one sheet of paper. His craftsmanship is immaculate and that is not a casual compliment if one thinks of the problems of combining perhaps six separate elements without trace of overlap.

The darkroom of course is where he indulges his sorcery and he finds the creative experience as actual and fulfilling there as behind a camera. He does take conventional photographs but is always alert for 'fragments', as he calls them, that he can perhaps use in his composite images.

He believes strongly in the need to trust his intuitive judgement and resists the urge to previsualise his final result too early, preferring to let it emerge gradually and always open to influence. The image is not assembled, it evolves.

He himself does not dwell on the symbolic content of his pictures and perhaps his most endearing quality is his open enjoyment of the element of play in his work.

A detailed description of Uelsmann's technique can be found in 'Darkroom', published by Lustrum Press, a collection of essays by a number of famous photographers on how they themselves develop and print.

Photographs by
JERRY UELSMANN

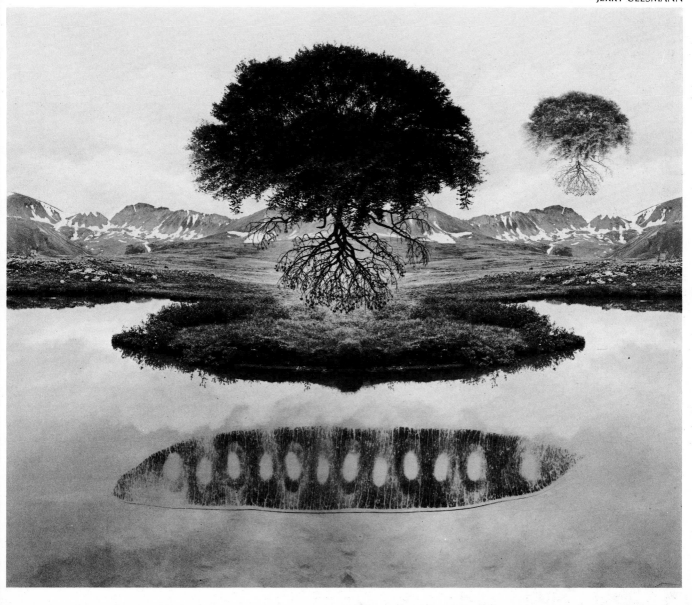

These three pictures do not simply explore the illusive qualities of photography, they rejoice in them. They are visual puns.

Ken Josephson photographs an image of a ship against the background of a real sea. We recognise that basic fact. But we are also aware that as readers we are one stage further removed from the situation than the photographer. We are looking at an image of a ship against an image of the sea.

Our appreciation of our dual response and our amusement at being so neatly involved in the description of shades of photographic reality, is the object of the exercise.

The same is true of the Heinrich Riebesehl picture, an equally deliberate and open conceit.

The photograph by Roger Vulliez is more of a puzzle and its ingenuity is enjoyable. But the most important point is not how it was done but our instinctive reactions to it, the tension it creates between our credulity and our common sense. The visual surprise we feel, shows how innocently we respond at first. Then we quickly adjust and try to analyse how we were fooled.

How was it done? A likely explanation is that a print of the original photograph was cut and the edges drawn back to give a wedge-shaped slit which was thinned down to a fine line at the end by retouching. A copy photograph was then made against a black background.

ROGER VULLIEZ

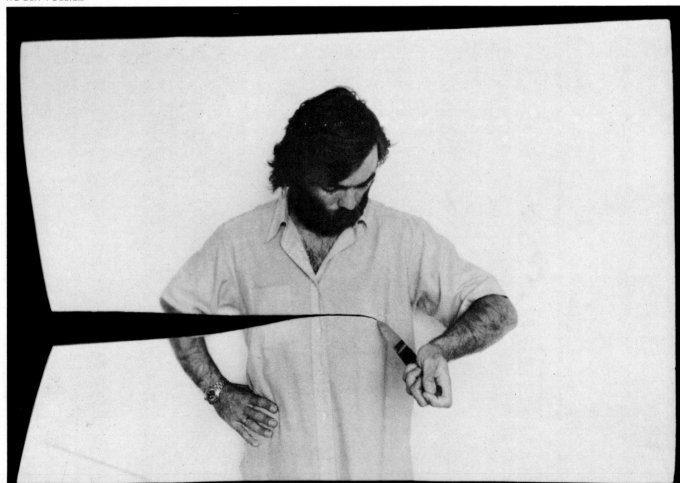

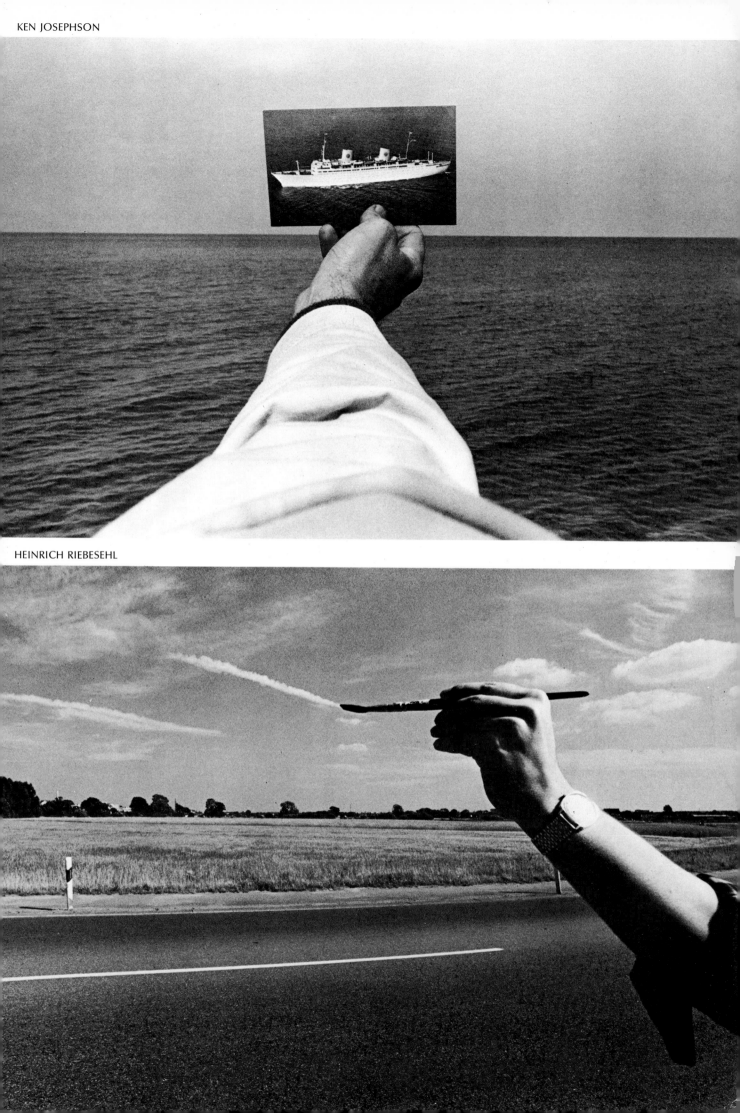

Acknowledgment is due to the following for permission to reproduce photographs:

Page

Front cover	Brian Brake/The John Hillelson Agency
4, 5	David Newell Smith/Observer
6	(left) Irving Penn/Copyright © 1948, 1976 by the Condé Nast Publications Inc.; (right) Brian Griffin
7	Duane Michals
8	(top Neal Slavin; (bottom) William Klein
9	Victor Musgrave
10	Irving Penn/Copyright © 1951 by the Condé Nast Publications Inc.
11	(top) Gunther Sander; (bottom) Arnold Newman
12	(top) Henri Cartier-Bresson/Magnum, from the John Hillelson Agency; (bottom) Elliott Erwitt/Magnum, from the John Hillelson Agency
13	Constantine Manos/Magnum, from the John Hillelson Agency
14/1	Leonard Freed/Magnum, from the John Hillelson Agency
14/2	Library of Congress
14/3	Georgia O'Keeffe/Portrait of O'Keeffe by Alfred Stieglitz, National Gallery of Art, Washington, on loan from Georgia O'Keeffe
14/4 & 5	Museum Ludwig, Köln, Graphische Sammlung
14/6	Hill and Adamson Collection, Edinburgh City Libraries
14/7	Sotheby's Belgravia
14/8	National Portrait Gallery
15	(left) Stone Collection, Birmingham Reference Library; (right) Gunther Sander
16	Bill Brandt
17	Burt Glinn/Magnum, from the John Hillelson Agency
18, 19	Joel Meyerowitz
20	Eve Arnold/Magnum, from the John Hillelson Agency
21	(top) Shirley Beljon; (bottom) Polaroid (UK) Ltd (photo Eric Hartmann/Magnum)
22	Harry Callahan
23	Dennis Stock/Magnum, from the John Hillelson Agency
24	Bill Brandt
25	Brian Griffin
26	Arnold Newman
27	Colin Jones
28, 29	Bradford Washburn
30	Fay Godwin
31	Bill Brandt
32	Bob Kauders
33	(top) Fay Godwin; (middle) René Burri/Magnum, from the John Hillelson Agency; (bottom) John Blakemore
34	(top) Gianni Berengo Gardin; (bottom) Raymond Moore/Robert Self Gallery
35	Fay Godwin
36	Bill Brandt
37	André Martin
38, 39	Ernst Haas/Magnum, John Hillelson Agency
40	Eliot Porter
41	André Martin
42	Georg Gerster/The John Hillelson Agency
43	Raymond Moore/Robert Self Gallery
44	Giorgio Lotti
45	(top) Robert Self Gallery; (bottom) Mario Giacomelli
46–48	John Blakemore
49	Mrs. Edna Bullock
50, 51	Susie Fitzhugh
52	Stephen Dalton
53	Chris Smith/Observer
54	Eamonn McCabe/Observer
55	(top) Joanna T. Steichen; (bottom) Prof. Marlis Steinert
56	Henri Cartier-Bresson/Magnum, from the John Hillelson Agency
57	Burk Uzzle/Magnum, John Hillelson Agency
58	Zoltan Glass
59	(top) Daily Telegraph Colour Library, Anthony Howarth/Alex Low; (bottom) Gerry Cranham
60, 61	Daily Telegraph Colour Library, Anthony Howarth/Alex Low
62–64	Ernst Haas/Magnum, from the John Hillelson Agency
65,–69,	Gerry Cranham
70, 71	(top) Duane Michals; (bottom) Carol James
72	Dr. Annamarie Schuh
73	Hans Silvester/Rapho
74, 75	W. Eugene Smith/Magnum distribution from the John Hillelson Agency
76–79	Ian Berry/Magnum, from the John Hillelson Agency
80, 81	Marc Riboud/Magnum, from the John Hillelson Agency
82, 83	Adam Woolfitt/Susan Griggs Agency
84–88	Bruno Barbey/Magnum, from the John Hillelson Agency
89	David Newell Smith/Observer
90, 91	Don McCullin
92, 93	David Hurn/Magnum
94, 95	Josef Koudelka/Magnum, from the John Hillelson Agency
96, 97	Abigail Heyman/Magnum, from the John Hillelson Agency
98, 99	Burk Uzzle/Magnum, from the John Hillelson Agency
100 & 104	David Plowden, from 'The Hand of Man on America' published by The Chatham Press. Copyright © 1971 by David Plowden
101	Robert Adams/Robert Self Gallery
102	Library of Congress
103	Bill Brandt
105	Joel Meyerowitz
106–107	Ernst Haas/Magnum, from the John Hillelson Agency
107	(top) Joel Meyerowitz
108	Ernst Haas/Magnum, from the John Hillelson Agency
109	Aaron Siskind and International Museum of Photography at George Eastman House
110	(top) William Klein; (bottom) Ken Josephson
111	Ralph Gibson
112	(top) Elliot Erwitt/Magnum, from the John Hillelson Agency; (bottom) Robert Frank
113	Raymond Moore/Robert Self Gallery
114	Robert Doisneau/Rapho
115	(top) Lee Friedlander; (bottom) Ikko Narahara
116	(top) Burk Uzzle/Magnum, from the John Hillelson Agency; (bottom) Robert Frank
117	Lewis Ambler/Robert Self Gallery
118	Bob Kauders
119	Lewis Baltz
120, 121	Chris Killip
122, 123	Tony Ray Jones/ the John Hillelson Agency
124	Mario Giacomelli
125	Romano Cagnoni
126	Edouard Boubat
127	Elliott Erwitt/Magnum, from the John Hillelson Agency
128–131	Paul Hill
132, 133	James Wedge
134	Andy Earl
135	Pierre Cordier
136	Polaroid (UK) Ltd (photo Douglas Holleley)
137	Minor White Archive, Princeton University, Princeton, N.J., USA
138	Duffy
139	Arnold Newman
140, 141	Jerry N. Uelsmann
142	Roger Vulliez
143	(top) Ken Josephson; (bottom) Heinrich Riebesehl

I would also like to thank Dorothy Bohm, Robin Fletcher, Jimmy Fox, Nigel McNaught, Gilvrie Misstear, Michael Rand, and the staff of The Photographers' Gallery, London for their help in obtaining photographs. I am particularly indebted to Sue Davies, John Hillelson and Gerry Badger for all their assistance. B.C.

144